# Shin Hanga
## The New Print Movement of Japan

Barry Till

Pomegranate
San Francisco

Published by Pomegranate Communications, Inc.
Box 808022, Petaluma CA 94975
800 227 1428; www.pomegranate.com

Pomegranate Europe Ltd.
Unit 1, Heathcote Business Centre
Hurlbutt Road, Warwick
Warwickshire CV34 6TD, UK
[+44] 0 1926 430111
sales@pomeurope.co.uk

Library of Congress Cataloging-in-Publication Data

Till, Barry.
    Shin hanga: the new print movement of Japan / Barry Till.
        p. cm.
    Includes bibliographical references.
    ISBN-13: 978-0-7649-4039-2
    1. Shin hanga (Art movement)  2. Color prints, Japanese--
    20th century. I. Title.
    NE1323.7.S55T55 2007
    769.952'09041--dc22

                                        2006029310

Pomegranate Catalog No. A136

Designed by Barbara Ziller-Caritey

Printed in China

16 15 14 13 12 11 10 09 08 07      10 9 8 7 6 5 4 3 2 1

Front cover: detail of Nomura Yoshimitsu (active
1920s–1930s), *Fushimi Imari Shrine,* 1931. See page 83.

Title page: detail of Yoshimoto Gesso (1881–1936),
*Bird and Persimmons,* n.d. See page 107.

Back cover: Kawase Hasui (1883–1957), *Unsen Peak, Hizen,*
1926. See page 71.

# Contents

# A Romantic Look at the Past

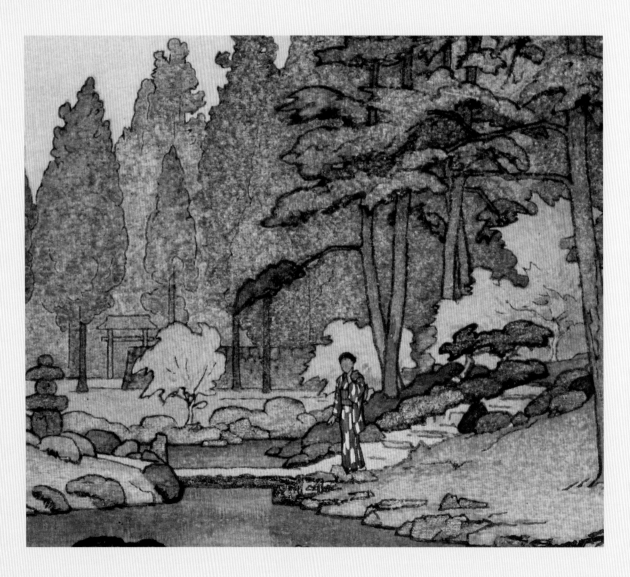

*S*HIN HANGA literally means "new prints." It is the name given to a Japanese print movement that had its heyday roughly from 1910 to 1960, with some vestiges continuing to this day. The *shin hanga* movement was a romantic look at the past that attempted to recapture the graceful beauty of the old *ukiyo-e* prints. These "new prints" have often been referred to as the autumn of *ukiyo-e,* neo-*ukiyo-e,* or *ukiyo-e* in a new form fused with contemporary styles of art and fashion. Perhaps the best phrase might be the renaissance of *ukiyo-e.* While *shin hanga* does have superficial similarities to *ukiyo-e,* it has a very distinct nature and deserves an important place in Japanese print history. *Shin hanga* prints are now being collected as never before; many prints have reached and surpassed some of their much older *ukiyo-e* counterparts in popularity and value.

### Ukiyo-e

Woodblock prints called *ukiyo-e* (pictures of the floating world) have a long, colorful history in Japan. They were hand-colored woodblock prints or multiblock color prints, which were cheaply produced in great numbers as affordable art for the lower and middle classes. The main subject matter of these prints includes theater performers, courtesans, landscapes, birds and flowers, scenes of everyday life, and historical events. The painter or sketcher was often given most of the credit for their production, but it was really a collaborative effort with block carvers, printers, and publishers or distributors. The popularity of the *ukiyo-e* extended as far as Europe, where the prints impacted the work of some impressionist and postimpressionist artists. As a source of inspiration and an example of unsurpassed techniques, these prints cannot be ignored by any artist.

### Meiji Japan (1868–1912)

The Meiji period (1868–1912) in Japan is one of the most interesting eras in modern history. Before Emperor Meiji's restoration in 1868, Japan was an isolated feudal country. By the time of his death in 1912, Japan had become a major power in the modern world. No other society in modern times

transformed itself so rapidly and so drastically. Every aspect of Japanese society was affected by this upheaval, which included a redirection of artistic energies. The art in the early years of Meiji rule was noted for its zealous emulation of Western artistic ideas and rejection of traditional Japanese art forms. With Emperor Meiji calling for the wholesale adoption of Western ideas by Japan, the days of traditional woodblock prints seemed numbered. The new era wanted a more realistic style of art than the outmoded *ukiyo-e* tradition. *Ukiyo-e* prints were slowly being pushed aside by Western-style engravings, etchings, lithographs, and photographs.

During the Meiji period, a fruitful exchange between Japanese and Western art began. Japanese arts and crafts, especially woodblock prints, were arriving in Europe on trade ships, as well as being displayed in international exhibitions. They provoked enormous enthusiasm among European artists and caused a profound change in their late nineteenth-century artistic ideas. The imported Japanese art spurred a fashionable trend known as "Japonisme" in various art forms. The Europeans were fascinated with the tremendous skill of the Japanese artists and craftsmen and their motifs. They were influenced by compositional devices such as the truncation of the major part of the subject, the use of solid areas of color and large empty spaces, the division of the composition into simple geometric areas, the vertical format, and the use of high or low viewpoint to bring the foreground and background into the same plane. Late nineteenth-century Western artists, such as Manet, Monet, Degas, Gauguin, van Gogh, Toulouse-Lautrec, Whistler, and Cassatt were greatly influenced by Japanese art.

The most progressive ideas in Western art developed in Paris during the late nineteenth century, and *ukiyo-e* prints played a role in this new movement. Manet was the first to adopt some aspects of the *ukiyo-e* print, particularly the portrayal of everyday activities and ordinary experiences. Monet's scenes of everyday life and his brilliant colors also show the influence of the *ukiyo-e* prints. Degas absorbed the unusual angles and points of view of the *ukiyo-e* prints.

From Japanese prints, Gauguin learned to use unusual shapes, such as the fan shape, for his paintings. The prints also inspired Gauguin to revive the color print, which Europeans had discarded

centuries earlier. He was convinced that the East Asian tradition could revitalize the art of color printing in the West. In Hiroshige's prints, van Gogh saw the decorative potential of brighter colors and the expressive power of large single-color areas. Van Gogh even painted direct copies of some Hiroshige prints. Toulouse-Lautrec was strongly influenced by *ukiyo-e* themes, and he, too, began to paint risqué scenes from the Parisian world of theaters, circuses, cabarets, and brothels. The influence was noticeable in his lithographs as well as his paintings. More than any other Western artist of the time, Toulouse-Lautrec embodied the true spirit of *ukiyo-e*.

For Whistler, *ukiyo-e* represented an ideal of inner calm and beauty. Japanese derivations are obvious in paintings such as *Nocturne: Blue and Gold—Old Battersea Bridge,* which is similar to scenes of bridges and fireworks in some *ukiyo-e* prints.

In 1891, Cassatt made ten etchings in direct imitation of *ukiyo-e* prints. Cassatt's etchings are excellent examples of the late nineteenth-century synthesis of Eastern and Western art.

While Japanese art was injecting new energy into Western art, the traditional arts in Japan were rapidly deteriorating due to overemphasis on Western realism, with its perspective, shading, and anatomical accuracy, which the Japanese considered more modern (and therefore more appealing) than their own traditional depictions.

The new Japanese art circles had a low opinion of *ukiyo-e* prints until they discovered the enormous impact they had on European impressionist and postimpressionist painting. Western respect for *ukiyo-e* led the Japanese artistic elite to take a second look at the old prints and the tradition they represented. Western recognition gave Japanese artists new respect at home and increased their confidence in traditional art. Artists began to see the value in preserving the legacy of *ukiyo-e*.

*Ukiyo-e* printing was all but dead by the early twentieth century, and Japanese artists were anxious to find a replacement. As a result, Japanese printmaking underwent a renaissance in two movements: the *sosaku hanga,* or "creative prints," movement and the *shin hanga,* or "new prints," movement. The *sosaku hanga* artists were more profoundly influenced by Western styles and techniques,

and in most cases worked alone. They believed that creative intent could not be transmitted from the artist through professional carvers and printers, and that the artist must create the print from start to finish in order to convey the original intention. The *shin hanga* artists wanted to build on the foundations of the traditional *ukiyo-e* school using new designs and subjects appropriate to the modern age. They preserved the custom of working in teams that included the artist, an engraver, a printer, and sometimes a publisher. Like *ukiyo-e, shin hanga* prints were produced as popular commercial products. They incorporated classic *ukiyo-e* subjects such as lovely women, Kabuki actors, and landscapes. In terms of sheer skill, the *shin hanga* craftsmen were every bit as good as their *ukiyo-e* counterparts, and succeeded in producing prints as versatile, as sensitive, and as fine in composition and in color.

### Watanabe Shozaburo (1885–1962)

The entire *shin hanga* movement owes its very existence to one man, a publisher named Watanabe Shozaburo. He initiated the movement and coined the phrase "*shin hanga*."

Watanabe was introduced to *ukiyo-e* prints at a very early age. When he was only eleven years old, he went to work in an antique store in Yokohama that specialized in selling *ukiyo-e* prints to foreigners. Growing up surrounded by beautiful *ukiyo-e* prints, Watanabe came to appreciate the consummate skill of the *ukiyo-e* masters.

In 1910, at the age of twenty-five, he opened his own antique print shop in Tokyo. Even though Watanabe actively cultivated sales outside Japan, he became quite concerned (and rightly so) that foreigners were buying up all the finest old prints, depleting Japan of its heritage. He hoped that he could educate the Japanese people to appreciate and understand Japan's great print tradition, and he encouraged Japanese art connoisseurs to have the foresight to collect traditional woodblock prints.

Because of the great demand, soaring prices, and the sudden shortage of *ukiyo-e* prints, several antique print dealers began publishing reproductions of traditional *ukiyo-e* prints to sell. Watanabe followed suit, producing reprints of the works of Suzuki Harunobu (c. 1724–1770), for which he had the

original blocks. However, he did recognize the value of producing new and original prints, and sought to revitalize the art of *ukiyo-e*. He started the production of new, original prints in 1915, calling them *shin hanga*. He later tried to introduce the term *shinsaku hanga,* or "newly created prints," but this label did not stick. *Shin hanga* remained the popular term.

An earlier print project commissioned by Watanabe was produced in 1907 by the artist Takahashi Hiroaki (1871–1945), who made a series of relatively small landscape prints suitable for calendar illustrations and greeting cards. These prints, which were obviously inspired by the great landscape *ukiyo-e* master Hiroshige Ando (1797–1858), are sometimes referred to as the first *shin hanga* prints. They met with reasonable success. In 1908, Watanabe added to his stock hundreds of bird-and-flower prints by Ito Sozan (1864–?), as well as the work of less notable artists such as Shun'yo, Kakei, Fuyo (1864–1936), and Shurei. These cheap little prints were more commercial products or illustrations than self-conscious works of art, and were often dismissed as "sweet and touristy."

Early on, Watanabe collaborated with a number of Western artists—such as Fritz Capelari in 1915, Charles W. Bartlett in 1916, and Elizabeth Keith in 1917—to make woodblock prints. The prints by Capelari might even be considered the first true *shin hanga* works of art. After seeing Capelari's prints, major Japanese artist Hashiguchi Goyo (1880–1921) was persuaded by Watanabe for the first time to convert one of his paintings into print form. Some regard Goyo as the first and the greatest *shin hanga* artist.

In 1915, Watanabe published a print design by Goyo entitled *Nude After the Bath*. However, after this collaboration, Goyo left Watanabe to gain greater technical and artistic control of the entire print-making process. He went on to design a small number of exceptionally good prints with meticulous technical standards before his untimely death in 1921 at the age of forty-one.

Shortly after his fallout with Goyo, Watanabe turned his attention to finding brilliant young artists he could mold. One such talented artist was Ito Shinsui (1898–1972), a student of a leading Japanese-style painter named Kaburagi Kiyokata (1878–1973). Starting in 1916, Watanabe commissioned Shinsui to produce prints of landscapes and pictures of beauties *(bijin-e)*. They would develop a close

**Detail of Kawase Hasui (1883–1957),**
*Late Snow Along Edo River,* **1932. See page 73.**

and fruitful relationship which would last until the death of Watanabe in 1962. Shinsui produced a huge number of *bijin-e* prints, displaying a great deal of realism in his treatment of the face and figure. He created a real sense of drawing "in the round."

Other talented *bijin-e* print artists with whom Watanabe occasionally collaborated include Yamakawa Shuho (1898–1944) and Kobayakawa Kiyoshi (1896–1948). They, like Shinsui, produced delicate female portraits with mildly erotic overtones. One of the few notable *bijin-e* artists who did not work with Watanabe was Torii Kotondo (1900–1976), who created beautiful prints of women styled after the works of Goyo and Shinsui. Torii Kotondo worked mainly with the joint publishers Sakai and Kawaguchi.

In 1916, Watanabe spotted a marvelous painting of a celebrated actor by Natori Shunsen (1886–1960) and helped to turn it into an extremely fine print. The two would work together on one other print and then would not collaborate again until eight years later. Never giving up, Watanabe searched out another painter of actors named Yamamura Toyonari (1885–1942), who studied at the Tokyo Art School. Watanabe began working with him in 1917 to produce some very fine actor prints, which updated and modified the style of the actor prints of the traditional *ukiyo-e* masters, such as Sharaku (active 1794–1795) and Toyokuni (1769–1825). Toyonari was very skillful at capturing three-dimensionality by embracing Western ideas of perspective and other design sensibilities, but he stopped designing prints in 1922.

In 1918, Watanabe began working with Kawase Hasui (1883–1957), another young pupil of Kiyokata. Hasui's first landscape prints met with critical acclaim. Hasui, too, would go on to have a long,

beneficial association with Watanabe. He was able to create dreamlike images of Japan—untouched by the uglier forms of modernization and industrialization—using a combination of Western and Japanese artistic techniques, which were exactly what foreign collectors, as well as some Japanese buyers, were interested in purchasing.

In 1920, Watanabe began publishing the landscape prints of Yoshida Hiroshi (1876–1950), who produced seven prints with Watanabe. Then, like Goyo, Hiroshi left Watanabe and employed his own woodblock carvers and printers, whom he meticulously supervised at every stage of the prints' production. He went on to design 249 more prints, earning an international reputation unparalleled by any other *shin hanga* artist. Among foreigners, Hiroshi is the best known and most loved of the *shin hanga* artists. His prints are often mistaken for watercolors because of the immense range of his shades and tones. Because of the tremendously varied soft, subtle colors, he was able to create a sense of depth and three-dimensionality. His prints involved painstaking efforts said to have been three times more labor-intensive than the production of an *ukiyo-e* print. He would bring *shin hanga* prints to a new level of excellence. Hiroshi traveled extensively and captured many wonderful scenes from the United States, Europe, Africa, India, Southeast Asia, China, and Korea, as well as spectacular scenes of Japan. It is never mentioned, but he also must have traveled in Canada, as he depicted Niagara Falls from the Canadian side and he made a print of Moraine Lake, which is in Canada.

Watanabe also produced prints in the field of nature studies. One of his favorite artists was Ohara (Koson) Shoson (1877–1945), who also worked for other publishers. His prints were naturalistic renderings with delicate use of line and skillful shading. Most of these were sent by Watanabe to Europe and America, as they do not appear to have been popular in Japan. Shoson was very prolific and produced a huge number of prints using various sizes.

Just when things were going so well for Watanabe and the fledgling *shin hanga* movement, the great earthquake of 1923 hit Tokyo. Watanabe's shop burned, and he lost his entire stock of prints as well as all of his original woodblocks. Fortunately, Watanabe was still an energetic man at thirty-eight,

and he remained deeply committed to the *shin hanga* cause. With a great deal of foreign encouragement and support, Watanabe was able to struggle back to his feet, thus assuring the survival of the movement. With this new start, he abandoned making reproductions of *ukiyo-e* and concentrated his entire effort on making *shin hanga* prints while gradually rebuilding his export trade.

Watanabe rekindled his collaborations with Shinsui and Hasui, and resurrected his relationship with Shunsen. They were all very aware of the tastes and preferences of their foreign clientele, and began producing large numbers of prints again. The Great Depression of 1929 did not help matters, as foreign demand dropped for a time.

Watanabe became one of the main suppliers of two incredibly popular and groundbreaking exhibitions of *shin hanga* prints at the Toledo Museum of Art in 1930 and 1936. Other *shin hanga* exhibitions took place in Paris, London, Warsaw, New York, and San Francisco, where they were very popular.

During the 1930s, there were few new artists working with Watanabe, with the exception of Hirano Hakuho (1879–1957) and Hasui's student, Ishiwata Koitsu (1897–1987), who seemed interested in moving into the *shin hanga* field to take over from the aging, well-known circle of *shin hanga* artists. In 1936 and 1937, Watanabe himself supervised the making of two prints based on photographs and signed them Watanabe Kako.

The first major setback for the *shin hanga* movement was the great earthquake of 1923, and the second was World War II. Just before and during the war, foreign demand for the prints collapsed and few new prints were made.

After the war, Watanabe's son and heir, Tadasu, took over the print store and did a booming business selling *shin hanga* prints to the occupation forces. The large stock of old prints sold well, and woodblocks that had not been published were immediately printed to meet the demand. However, few new *shin hanga* prints were being made, except for those by Shinsui, Hasui, and Shunsen. With the deaths of the four major players in the field—Hasui in 1957, Shunsen in 1960, Watanabe in 1962, and Shinsui in 1972—the movement was finished.

The *shin hanga* movement lasted about fifty years, from 1910 to about 1962, with its glory days from 1915 to 1937. *Shin hanga* was the last flowering of traditional realistic prints, and with the death of its greats, the romantic look at Japan's past through prints was finished. After the war, *sosaku hanga,* or "creative prints," displaced *shin hanga* in popularity. *Sosaku hanga* artists such as Munakata Shiko (1903–1975) and Saito Kiyoshi (1907–1997) were winning many awards at home and abroad.

Almost all the great *shin hanga* artists collaborated with Watanabe at one point or another. The characteristics of Watanabe's collaborations include technical challenges and fine, handmade paper. Other common features include the use of a *goma-zuri* background, where the printer uses the edges of the baren (an oiled, circular pad wrapped in a sheath of bamboo fiber) to create dense coils or swirls of darker color against an otherwise plain background. In addition, his nature studies of birds often showed embossing of the feathers.

## Foreigners Using the Japanese Woodblock Techniques

In the early twentieth century, a number of European and American artists in Japan and China began producing color woodblock prints using the *ukiyo-e* method with a team of carvers and printers.

Among the most successful Europeans was an Austrian, Fritz Capelari (1884–1950). In 1915, Capelari was one of the first artists to work with Watanabe to produce prints based on his paintings. This collaboration was instrumental in the popularization of *shin hanga,* as Watanabe would persuade Japanese artists to try the woodblock print medium by showing them Capelari's prints, which suggested the potential for their own work.

Watanabe also persuaded the British painter and etcher, Charles W. Bartlett (1860–1940), to convert his paintings into woodblock prints. In 1916, many of Bartlett's watercolors of Indian scenes were turned into prints and were commercially quite successful.

Another British artist, Elizabeth Keith (1887–1956), came to visit her sister in Japan in 1915, and would stay for nine years, traveling and making watercolors. In 1919, Watanabe saw the potential of

converting her paintings into prints. Her prints, more than sixty of which were made, had rich texture and color and an incredible sense of depth. The subjects Keith chose to represent were mainly architectural scenes or genre scenes from Korea, China, and occasionally the Philippines.

A British artist who might be very loosely placed in the *shin hanga* vein was Katharine Jowett (c. 1890–1965), of whom little is known. She lived in Beijing and produced Chinese scenes with linoleum cuts using oil colors. Her prints show interesting, soft, blurry images within a dark heavy border.

The French artist Paul Jacoulet (1902–1960), whose father was a language tutor in Japan, spent much of his life in Japan. He produced some amazing portrait prints of Asians, especially beautifully clothed people from China, Korea, Japan, and the South Pacific. Jacoulet hired one of Japan's finest carvers, Maeda Kentaro (active 1930s), to carve the blocks for his paintings. His prints, with a style deriving from art deco, made daring use of bright, bold colors and paid immaculate attention to surface detail. He produced a huge number of prints, which eventually sold very well to the occupation forces after 1945.

Of the American artists using the Japanese woodblock technique, the most famous were Helen Hyde (1868–1919) and Bertha Lum (1869–1954). Hyde, a San Francisco artist, lived and worked in Asia, mainly Japan, for nearly fifteen years. She made use of the skilled Japanese block carvers and printers to produce delicate genre pictures of Japan. Lum, a midwesterner, came to Japan on her honeymoon. She learned how to use carving tools, and would produce a few of her own prints. In 1911, she moved to Tokyo and began to work with skilled carvers and printers. Like Hyde, she depicted wonderful genre scenes with subtle colors, as well as scenes of fantasy—usually with thick outlines.

Another American, Cyrus LeRoy Baldridge (1889–1975), who traveled to Japan in 1924 and 1925, collaborated with Watanabe to produce six interesting woodblock prints of Beijing scenes.

Another artist working in the Japanese *shin hanga* era was Pieter Irwin Brown (1903–?) of Dutch-Irish parentage, who worked in Japan around 1936. He produced images of China with dark colors.

One Japanese *shin hanga* artist who may be placed with foreigners is Urushibara Yoshijiro

(1888–1953), who spent thirty years in London and Paris using traditional Japanese woodblock techniques to publish many delightful flower still life pictures. He influenced a number of artists studying in Europe, including John Platt (1866–1944) and the Canadian artist W. J. Phillips (1884–1963). He also helped turn many of the paintings of Frank Brangwyn (1867–1956) into prints.

## Landscape Prints

*Shin hanga* artists produced some of the most amazing, realistic landscape prints the world has ever seen. They were quite different from the traditional prints of their *ukiyo-e* predecessors. All around the *shin hanga* artists were Western-style buildings and modern industries. What they tried to accomplish was to record the natural splendor and warmth of old Japan as it was disappearing at an astonishing speed before their very eyes. They held in great esteem traditional buildings and the quaint settings of rural villages. They romanticized the life of the townspeople and their environment, and paid special attention to idealized scenes that depicted the magnificence of nature. They sought to restore Japan's picturesque traditional scenery to the hearts and minds of the Japanese people, and to create a sense of pride in their country's heritage. They hoped their prints would be a visual remedy to Japan's speedy Westernization, especially in Tokyo.

Their prints were offered as an updated version of the traditional prints, using Western concepts of space, light, and volume. By employing this synthesis of tradition and modernity, the *shin hanga* landscape artists hoped to create a new national identity of which the Japanese could be proud. They revisited *ukiyo-e* landscapes, using Western artistic techniques and aesthetics in conjunction with Eastern sensibilities. The result was an incredible and unique amalgam combining the best of two artistic worlds.

Of the successful *shin hanga* artists who produced landscape prints, two stand head and shoulders above everyone else: Yoshida Hiroshi and Kawase Hasui. Both worked with Watanabe, but while Hasui remained with Watanabe and his staff, Hiroshi decided in 1925 to become independent and hired

his own staff of block cutters and printers. The two artists would become major rivals for the domestic Japanese market, with Hiroshi tending to dominate the international market.

Hiroshi was one of the most talented Western-style painters in Japan and had a number of successful exhibitions of his oils and watercolors in the United States. He was inspired by Turner, Constable, and the French impressionists, and was both an admirer and a critic of Whistler. Hiroshi was influenced by the traditional beauty of *ukiyo-e* and was indebted to Hiroshige for his strong sense of design and skill at effective placement. He became keenly aware of the influence of Japanese prints on impressionism and postimpressionism in the West. When he turned to the medium of woodblock printing at the age of forty-four, he devoted all of his energy to the process and sought to merge the artistic concepts of the West and the East. He was a creative genius who developed a number of new techniques and innovations in the print medium. He took extreme care that his prints had a uniformly high quality, destroying any print with which he was not completely satisfied. His painstaking efforts sometimes involved making as many as ninety-six color print impressions to create a single print. The process sometimes involved several impressions of similar or contrasting colors on the same blocks. He exhibited endless care, skill, and patience. He loved to show the changes of the time of day and would often use the same blocks with different pigments to create the moods of the day: the freshness of the morning or the cool shades of the evening.

Printmaking was a labor of love for him and he felt the only way he could ensure the highest quality of the print was to personally supervise each stage of the process. The most notable of his block carvers were Yamagishi Kazue (1883–1966) and Maeda Yujiro (1889–1957). Yoshida Hiroshi occasionally printed on silk, used zinc plates for fine details, and used woodblocks made of woods other than the usual cherry. He is even known to have carved some of his own blocks for his prints and to have developed the color shades and tones for the pigments which were used. This large palette of merging pigments and tones allowed him to achieve a real sense of three-dimensionality. His prints were quite different from the clear black borderlines found in the *ukiyo-e* landscape prints, which were markedly two-

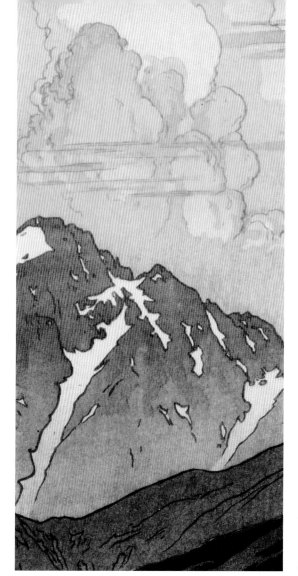

Detail of Yoshida Hiroshi (1876–1950), *Tsurugizan, Morning,* 1926. See page 40.

dimensional. On the prints which he supervised from start to finish, he placed the mark *jizuri* (self-printed). The ones that do not have this mark were produced without his supervision.

Hiroshi was one of the few Japanese *shin hanga* artists to depict foreign scenes. He was able to finance his trips to North America, Europe, Africa, Southeast Asia, China, and Korea through the sale of his paintings and prints. He took much joy in depicting the natural wonders of North America, the magnificent mountains of Europe, the architectural marvels of ancient times (the sphinx in Egypt and the acropolis ruins in Greece), and the stunning religious monuments of India and Southeast Asia. In Japan, too, he would travel extensively on hiking trips, sketching majestic mountains, quaint countryside scenes, and architectural wonders. He was a true master at capturing the essence of water, whether it be a busy seaport, a trickling stream, or a tranquil lake. Hiroshi excelled at conveying the calmer moments of nature in the very personal, quiet mood of his designs.

Hiroshi was extremely prolific and very successful in the West. At the special 1930 exhibition of *shin hanga* prints at the Toledo Museum of Art, of the 342 prints on display, 113 were by Hiroshi. At the second Toledo exhibition in 1936, his accounted for 67 of the 289 prints. He can truly be credited with revitalizing Japanese printmaking at a time when Western influence was threatening all forms of traditional Japanese art. Hiroshi built cultural bridges between nations and reversed the decline of printmaking in Japan.

Yoshida Hiroshi's family's association with the arts is worth noting. His adoptive father, Yoshida Kasaburo (1861–1894), was an art teacher; Kasaburo's daughter, Fujio (dates unknown), whom Yoshida would marry, was also a talented painter. They produced a third generation of artists: Toshi, a noted *shin hanga* and *sosaku hanga* artist, and Hodaka, a successful *sosaku hanga* artist. Both sons would marry artists and they, too, would give birth to another generation of artists.

Yoshida Hiroshi's son, Yoshida Toshi (1911–1995), succeeded his father in the *shin hanga* field and lived in a manner much like his father—traveling around the world in search of subjects. Toshi was greatly influenced by his father's work and learned the skills of carving blocks and various printing techniques from him. He would become a very accomplished printmaker, who knew how to make use of light and texture to produce simple yet charming landscapes and genre scenes. His prints have an unpretentious sense of nostalgia, and some of his architectural depictions with subdued colors employ very interesting points of view which are most attractive. His prints seem to vary in mood from bright optimism to dark pessimism.

In 1966, he made a drastic about-face. He became a convert to abstract art in the *sosaku hanga* field and condemned both late *ukiyo-e* and *shin hanga,* writing in a book:

> After the death of the last great masters, chiefly Hokusai and Hiroshige, the traditional art no longer possessed any potential drive, and the publisher-artist-artisan system of print making became nothing but a barrier restricting the freedom of the artist. . . .It may be said that the modern print *(sosaku hanga)* movement started as a drastic reaction to the decadence of the *ukiyo-e,* which had become over-ripe in technical skill but quite impoverished in artistic value.[1]

Toshi would make nearly 300 abstract prints, but would end his career making prints of scenic landscapes and animals in a vibrant realistic style, traveling to exotic places such as Africa and Antarctica. In 1980, Toshi opened a printmaking school in Nagano Prefecture, which was attended by a

[1] Yoshida Toshi and Yuki Rei, *Japanese Print-making: A Handbook of Traditional and Modern Techniques* (Rutland, VT: C. E. Tuttle, 1966) p. 87.

large number of international students, some of whom would become famous printmakers themselves. He also often traveled abroad to give workshops.

The other great landscape artist of the first generation of *shin hanga* artists was Kawase Hasui. He was a shy but hardworking pupil of the Japanese-style artist Kaburagi Kiyokata. He wore thick eyeglasses and preferred to wear a kimono rather than a Western suit. In 1918, Hasui was persuaded by Watanabe to turn his paintings into woodblock prints. This venture was immediately successful. Hasui showed great sensitivity and skill at depicting snow, rain, sunrises, and sunsets. His architectural studies were excellent, as were his depictions of water scenes. He was most admired for his quiet snow scenes and indigo night views. Hasui combined traditional *ukiyo-e* elements with Western aesthetics to create original prints which employed Western perspective but were distinctly Japanese. His prints were exceedingly complex and his overprinting sometimes involved as many as twenty-five blocks per print.

While painting, Hasui was always aware that his picture would be turned into a print. He said he actually began visualizing his prints while he looked at the landscape—even before he put brush to paper. He wrote of his print production as follows:

> I draw the original thinking of the final product. There are occasions when the final prints do not measure up to original expectations. There are also happy occasions when the prints turn out to be superior to original paintings because they are prints.
>
> As true with any occupation, it requires training. One must try hard constantly. There can be no relaxation at any time. One must work diligently throughout life.
>
> Woodblock prints in particular involve the work of more than one person. It is like *gidayu* [Japanese puppetry] with puppet handlers, singers and musicians.
>
> There is no problem if the carver carves faithfully in accordance with the artist's design. It is quite troublesome if the carver tries to express his own individuality. Carving faithfully requires experienced technical hands.

In the case of printing we must interact very closely. A less experienced printer might waste seven or eight trial prints before a most talented one is made. If someone is experienced we can decide on the final print after two or three trials. It occurs occasionally that, despite best efforts, a successful print is still not produced. This is the hard part of composite art. It requires telepathic communication. Unless all parties are completely in tune, the process will not work. When my mind and the minds of the artisans are in complete agreement, a good work can be generated.[2]

Hasui mainly designed prints for Watanabe, but he did design for other publishers and made an income from the sale of his original watercolors. His prints before 1923 are extremely rare, as most of his prints and woodblocks were destroyed in the great earthquake. Hasui has often been compared to Hiroshige, for both loved to depict their extensive travels throughout Japan, with its incredible natural beauty. Up until his death (caused by cancer) in 1957, Hasui was considered to be one of Japan's greatest living artists. Shortly before his death, he was recognized as a "living national treasure" by the Japanese government.

Hasui had no children and few students. The most talented of his students was Ishiwata Koitsu (1897–1987). Like Hasui, he made beautiful landscapes depicting all types of weather conditions, all times of day and night, and was very effective at conveying the moods of the changing seasons. Also like Hasui, he dealt with simple scenes taken from everyday life, mainly of common people and farmers, but occasionally he did show the bright lights of the city.

Another *shin hanga* landscape artist with the same name was Tsuchiya Koitsu (1870–1949), a student of noted *ukiyo-e* artist Kobayashi Kiyochika (1847–1915). He produced delightful landscapes with interesting angles and often placed figures in his depictions. His landscapes were usually tranquil, but he sometimes depicted modern-day scenes of the city with its skyscrapers and automobiles. He was very successful at fusing elements of the past with the realities of modern Japan. Koitsu, who also

[2] Irwin J. Pachter, *Kawase Hasui and His Contemporaries: The "Shin Hanga" (New Print) Movement in Landscape Art* (Syracuse, NY: Everson Museum of Art, 1986), pp. 25–26.

Detail of Kasamatsu Shiro (1898–1991),
*Evening Rain, Yanaka Pagoda, Tokyo,* 1932.
See page 80.

worked with Watanabe, was one of the more prolific *shin hanga* artists of the 1930s. He was noted for his technical sophistication and tremendous output.

Another *shin hanga* landscape artist of note is Kasamatsu Shiro (1898–1991), who was a student of Kiyokata and published prints with Watanabe. He produced a number of interesting townscapes, often showing the interiors of buildings. However, by the 1950s, he became interested in the ideals of the *sosaku hanga* movement and began carving and printing his own blocks. His work became less realistic and more impressionistic.

Nomura Yoshimitsu (active 1920s–1930s) was another talented *shin hanga* landscape artist. His prints, which display an excellent sense of panoramic space, show the influence of his French art teacher. He specialized in landscapes and scenes of Kyoto. He was published by Sato Shotaro (active 1890s–1930s), who is also regarded highly in the *shin hanga* movement.

Other *shin hanga* landscape artists who deserve mention include Narazaki Eisho or Fuyo (1864–1936), Bannai Kokan (1900–?), Ito Yuhan (1882–1951), Furuya Taiken (active 1930s) and Oda Kazuma (1881–1956), who was a *sosaku hanga* artist working in the *shin hanga* realist style and did some prints for Watanabe.

One of the first *shin hanga* landscape artists to have success, especially in the export market, was Takahashi Hiroaki. He worked in a wide variety of sizes, from postcard size and long, narrow prints to the full-size *oban* format. It is said that between 1907 and 1923 he created nearly five hundred prints for Watanabe. After studying the techniques of the *ukiyo-e* masters, he succeeded in producing idyllic tourist landscapes. Later, in the 1920s, he made some extremely fine landscapes often depicting rain or snow. He also produced some interesting *bijin-e* prints.

### Bijin-e (Pictures of Beauties)

In portraits of women, the *shin hanga* artists excelled, producing prints with tremendous visual appeal. They harmonized the two-dimensional features of the classic beauties of *ukiyo-e* with Western concepts of space, light, and volume. The result was a feeling of naturalism "in the round" or three-dimensionality. The dark "iron-wire" outlines of the *ukiyo-e* faces gave way to more natural faces with soft, modulated color lines. The women of *shin hanga* prints seemed more refined, dignified, and respectable than their *ukiyo-e* counterparts. The *shin hanga* beauties were usually portrayed while bathing or applying makeup, and they show slight signs of eroticism. In particular, the treatment of shiny, cascading hair was quite exquisite.

There were a few late *ukiyo-e* artists, Mizuno Toshikata (1866–1908), Toyohara Chikanobu (1838–1912), Yamamoto Shoun (1870–1965), Tsutsui Toshimine (1863–1934), Kaburagi Kiyokata, Takeuchi Keishu (1861–1942), Ikeda Terukata (1883–1921), and Ikeda Shoen (1886-1917), who could be considered precursors to *shin hanga bijin-e* prints, as they produced more naturalistic and updated images of beauties in the late nineteenth and early twentieth centuries than earlier *ukiyo-e* artists.

The greatest of the *shin hanga* artists to make *bijin-e* was Hashiguchi Goyo. Early in his career, he trained as a Western-style painter and won awards for his skillful compositions. He painted in a style similar to the French academicians of the early twentieth century. As mentioned earlier, Watanabe persuaded Goyo to convert a painting into a print in 1915. However, Goyo became obsessed with high standards and with having full control of the printmaking process, so he soon left Watanabe to set up his own studio where he would personally supervise the carving of the blocks and the production of each print. He produced only small editions and hence his prints are quite rare and valuable.

Goyo became a collector and connoisseur of *ukiyo-e* prints and, having jointly edited a major book on the subject, had an extensive knowledge of them. He admired the classic works of Torii Kiyonaga (1752–1815) and Kitagawa Utamaro (1753–1806), and used a powdered mica background similar to the prints by Utamaro and Eisoshai Choki (active c. 1786–1808). Goyo's prints were much softer and more

elegant than his *ukiyo-e* predecessors and have a definite feel of three-dimensionality. He paid great attention to detail—especially in the hairstyles and kimonos worn by his subjects. His favorite model was Nakatani Tsuru (n.d.), a waitress at an Osaka restaurant. She is always seen in mysterious and sensual poses. Goyo did create some outstanding landscapes, but he is most remembered for his female figures. Unfortunately, he was often in frail health, suffering from beriberi and its complications. He died at the early age of forty-one. He completed only fourteen different subjects. Due to their scarcity, his prints are very valuable. Because of the great demand for his prints, his family had some of his unfinished images completed and posthumously published.

The second most significant *shin hanga* artist to produce pictures of beauties was Ito Shinsui, who worked with Watanabe all his life. Shinsui, like Goyo, painted his beauties "in the round" and was able to successfully combine Western and Eastern techniques. By using uneven shading, he created a sense of three dimensions. His beauties demonstrate a delicate decadence and an appealing charm—they are full of youthful innocence. For background, he used *goma-zuri,* in which circular traces of the printer's baren edge create a special swirling or coiling effect of darker color against a plain ground. He was also exceptionally talented when it came to making landscape prints. During his lifetime, he was recognized as one of Japan's greatest living artists.

Another outstanding *shin hanga* artist who produced *bijin-e* was Torii Kotondo, a descendant of Torii Kiyonobu (active 1720s–1760), founder of the famous Torii *ukiyo-e* school, which was noted for portraits of Kabuki actors. His prints were published by Sakai and Kawaguchi. At first he designed prints after Goyo and Shinsui, but soon he developed his own unique style. He depicted women of all walks of life, portraying them in an aloof and refined manner. His prints have a soft, flushed color and are noted for beautiful lines, as well as for his sumptuous, detailed, and complex depictions of kimono patterns. He often depicted women nude or fixing their hair.

Kobayakawa Kiyoshi, an accomplished *nihonga* or Japanese-style painter, published his *bijin-e* prints with Watanabe and Hasegawa while still a young man. His prints show beauties against a plain

background. He tried to update his images of beauties, often with a playful hint of eroticism. For example, in his 1930 print entitled *Tipsy,* the subject holds a cigarette over a cocktail. His subjects had both traditional and up-to-date hairdos.

Hirano Hakuho, a self-taught *nihonga* artist, designed prints for Watanabe in the mid–1930s. The faces of his subjects were seldom seen, as he liked to portray women with their backs or sides to the viewer. Little is known of him.

Other notable *shin hanga* artists who depicted beauties include Yamakawa Shuho, another of Kiyokata's outstanding students. He produced prints of elegant women with elaborate hairstyles, often on a mica background, for Watanabe in the 1920s and 1930s. Shima Seien (1892–1970), an accomplished female artist, produced a small number of very impressive *bijin-e* prints, showing great attention to facial features. She was married to a bank employee and lived in various places in Japan and abroad. Shimura Tatsumi (1907–1980) was another *bijin-e* print artist with great talent. He was mainly a painter and an illustrator for a women's magazine, but occasionally made prints with a very distinctive and individual style.

## Yakusha-e (Actor Prints)

The most prolific of the *shin hanga* artists who made Kabuki actor prints were Natori Shunsen and Yamamura Toyonari.

Shunsen studied with a number of Japanese-style painters. In 1916, he was approached by Watanabe to convert his actor paintings into woodblock prints. His prints were obviously inspired by the greatest *ukiyo-e* actor printmaker, Sharaku, but his genius in updating the genre was stunning. After their initial collaborations, Watanabe and Shunsen would not work together again until eight years later, when they would forge a long and profitable relationship. Between 1925 and 1929, Watanabe produced thirty-six of Shunsen's actor prints. These prints established Shunsen as one of the greatest artists of the genre, and he went on to receive numerous international awards. After World War II, he continued to produce a large number of exciting actor prints in collaboration with Watanabe. Tragically,

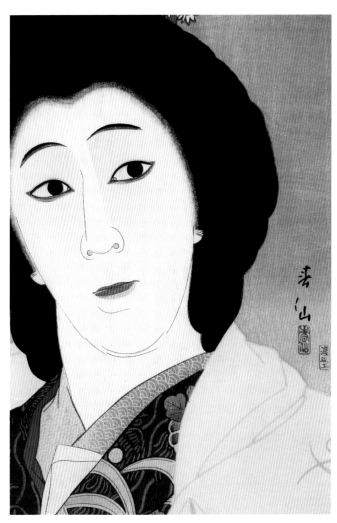

**Detail of Natori Shunsen (1886–1960),**
*Onoye Baiko as Sayari,* 1925. See page 96.

in 1958, his beloved twenty-two-year-old daughter, Yoshiko, died of pneumonia, and he never recovered emotionally. On March 30, 1960, he and his second wife committed suicide at the family grave in Tokyo.

Toyonari, the other renowned designer of actor prints, originally studied with the great *ukiyo-e* artist Ogata Gekko (1859–1920) before he went on to design a fairly large number of actor prints for Watanabe, starting in 1920. Toyonari's prints were very dynamic and powerful, but he also produced some comical caricatures of the actors. He also was fond of portraying the actors in profile. At first his prints were released in small editions of 150, but then the print runs became much larger.

Yoshikawa Kanpo (1894–1979) was another of the great artists working in the actor print genre. He was personally involved with the Kabuki theater as a stage designer, as well as being an advisor to a prominent theater company. He designed several memorable actor prints for the publisher Sato Shotaro.

Of the late *shin hanga* artists who produced actor prints, Torii Tadamasa (1904–1970) and Ota Masamitsu (1892–1975) were the best known and most competent. Masamitsu, in particular, portrays powerful images with a confident crispness in line and color. In contrast to other *shin hanga* actor designers, he often included interesting backgrounds behind his figures. A modern artist named

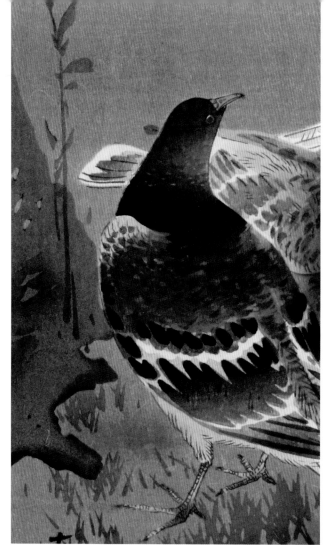

Detail of Ohara Shoson (1877–1945),
*Pigeons,* n.d. See page 104.

Tsuruya Kokei (b. 1946) has been producing actor prints in the *shin hanga* vein, but with a great deal more humor than his predecessors.

Another distinctive designer of actor prints was Tsukioka Kogyo (1869–1927), who was the stepson of the great *ukiyo-e* master Tsukioka Yoshitoshi (1839–1892). He learned the basic elements of print design from his stepfather and Ogata Gekko. Kogyo was unique in that he chose to illustrate Noh dramas rather than the customary Kabuki plays. His prints presented the entire figure and sometimes scenes, rather than the head or bust. He produced a huge number of prints based on Noh dramas, as well as some nature studies.

### Kacho-e (Bird-and-Flower Prints or Nature Studies)

*Kacho-e* was a popular subject of the *ukiyo-e* artists, but does not appear to have been as popular with the *shin hanga* movement. Many of these were produced in the early twentieth century, but they appear to have been destined more for the foreign market than for a Japanese clientele.

Watanabe realized the potential of the nature prints and commissioned a number of them from Ito Sozan, who tended to prefer a long, rectangular format for his prints. The birds in his prints are often found perched on branches. Little is known about Sozan. Before the great earthquake of 1923, Sozan was Watanabe's favorite *kacho-e* master, but around 1926 Watanabe replaced him with Ohara (Koson)

Shoson, who became the undisputed master of nature prints. Koson, a painter in the naturalistic style of the Shijo school, changed his name to Shoson in 1911 or 1912. He had been encouraged by Ernest Fenollosa (1853–1908), the great American advocate of traditional Japanese arts and crafts at Tokyo Imperial University, to take up printmaking. Shoson started with Russo-Japanese war prints, but soon went on to design bird-and-flower prints. Initially he designed prints only for Watanabe, but later used other publishers. He produced a seemingly endless number of prints in large editions. His prints vary in quality, but generally his earlier prints are more highly esteemed. His finest prints show an incredible skill and a meticulous attention to detail.

Other bird-and-flower printmakers include Yoshimoto Gesso (1881–1936), Soseki Komori (active early twentieth century), and Fuyo. Fuyo, also known as Eisho Narazaki, had been a professional copper-plate printer working for the government; he designed many prints of birds and flowers, as well as city genre scenes, for Watanabe.

# Bibliography

Brown, Kendall H., and Hollis Goodall-Cristante. Shin-Hanga: *New Prints in Modern Japan*. Los Angeles: Los Angeles County Museum of Art, 1996.

Hamanaka, Shinji, and Amy Reigle Newland. *The Female Image: Twentieth Century Prints of Japanese Beauties*. Leiden: Hotei, 2000.

Hillier, Jack Ronald. *The Japanese Print: A New Approach*. Rutland, VT: C. E. Tuttle, 1960.

Illing, Richard. *The Art of Japanese Prints*. London: Octopus, 1980.

Jenkins, Donald. *Images of a Changing World: Japanese Prints of the Twentieth Century*. With Gordon Gilkey and Louise Klemperer. Portland, OR: Portland Art Museum, 1983.

Merritt, Helen, and Nanako Yamada. *Guide to Modern Japanese Woodblock Prints: 1900–1975*. Honolulu: University of Hawaii, 1992.

Miles, Richard. *Elizabeth Keith: The Printed Works*. Pasadena, CA: Pacific Asia Museum, 1991.

———. *The Prints of Paul Jacoulet: A Complete Illustrated Catalog*. Pasadena, CA: Pacific Asia Museum, 1982.

Newland, Amy, and Chris Uhlenbeck (eds.). Ukiyo-e to Shin Hanga: *The Art of Japanese Woodblock Prints*. Wigston, Leicester: Magna, 1990.

Neuer, Roni, and Herbert Libertson. *Autumn of Ukiyo-e, Masters of the Early Twentieth Century*. New York: Ronin Gallery, n.d.

Pachter, Irwin J. *Kawase Hasui and His Contemporaries: The Shin Hanga (New Print) Movement in Landscape Art*. With Takushi Kaneko. Syracuse, NY: Everson Museum of Art, 1986.

Pickard Jr., W. H. *Twentieth Century Japanese Prints*. Darlinghurst, Australia: Antiquarian, n.d.

Smith, Lawrence. *The Japanese Print Since 1900: Old Dreams and New Visions*. London: British Museum Publications, 1983.

Stephens, Amy Reigle (ed.). *The New Wave: Twentieth-Century Japanese Prints from the Robert O. Muller Collection*. London: Bamboo, 1993.

Till, Barry, and Paula Swart. *The Legacy of Japanese Printmaking*. Victoria, British Columbia: Art Gallery of Greater Victoria, 1986.

Toledo Museum of Art. *A Special Exhibition of Japanese Prints*. Toledo, OH: n.p., 1930.

———. *Modern Japanese Prints*. Toledo, OH: n.p., 1936.

Yoshida, Hiroshi. *The Complete Woodblock Prints of Yoshida Hiroshi*. Text by Ogura Tadao, et al. Tokyo: Abe Publishing, 1991.

Yoshida, Toshi, and Yuki Rei. *Japanese Printmaking: A Handbook of Traditional and Modern Techniques*. Rutland, VT: C. E. Tuttle, 1966.

**Above:** detail of Ohara Shoson (1877–1945), *Swallows and Bee,* n.d. See page 103.

**Opposite:** detail of Natori Shunsen (1886–1960), *Nakamura Fukusuke as Smuggler Soshichi,* 1925. See page 95.

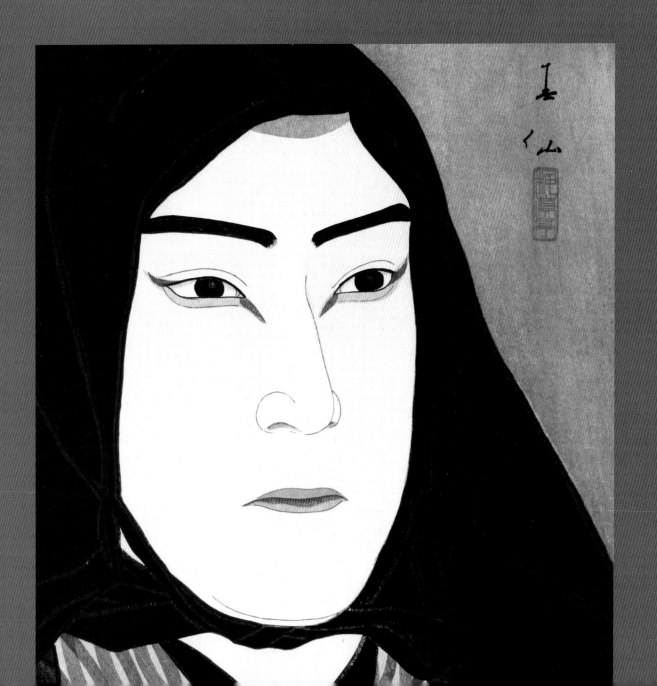

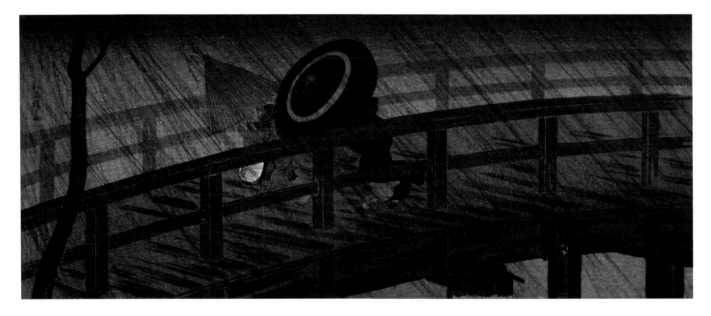

*Above:*
**Takahashi Hiroaki (1871–1945)**
*Night Shower at Izumi Bridge,* 1932
Woodcut on paper
Anonymous gift
AGGV 1968.077.001

*Opposite left:*
**Takahashi Hiroaki (1871–1945)**
*Shower at Terashima,* 1936
Woodcut on paper
Senora Ryan Estate
AGGV 1991.052.020

*Opposite right:*
**Takahashi Hiroaki (1871–1945)**
*Tenjin Shrine at Yushima,* 1936
Woodcut on paper
Senora Ryan Estate
AGGV 1991.052.016

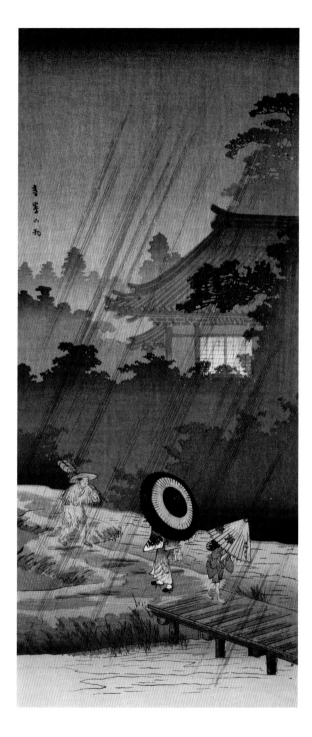

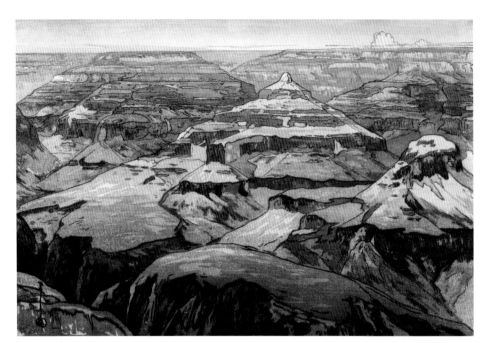

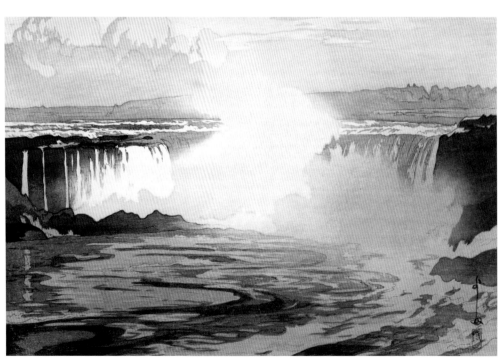

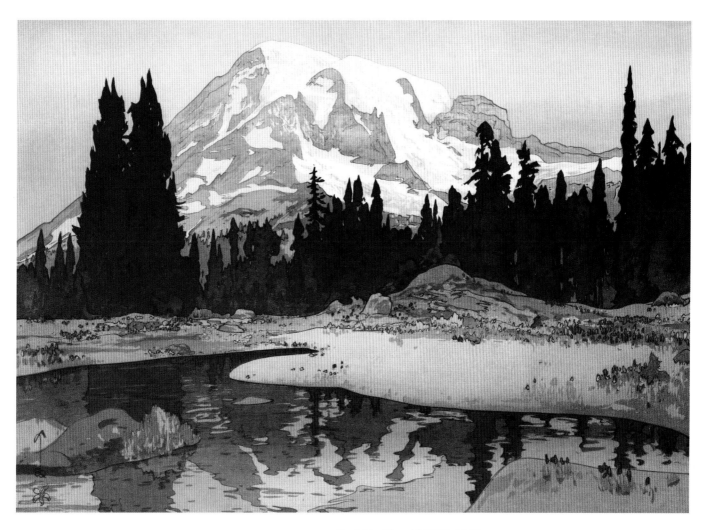

**Yoshida Hiroshi (1876–1950)**
*Mount Rainier,* 1925
Woodcut on paper
Fred & Isabel Pollard Collection
AGGV 68.210

**Yoshida Hiroshi (1876–1950)**
*Lake Moraine,* 1925
Woodcut on paper
Gift of George and Lola Kidd
AGGV 98.13

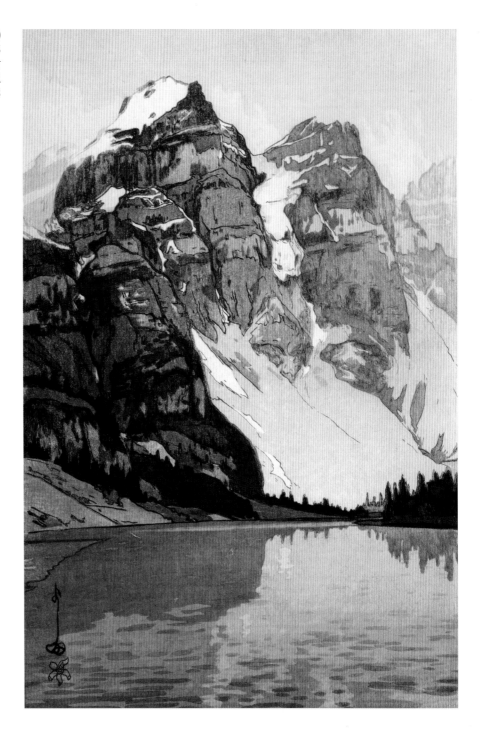

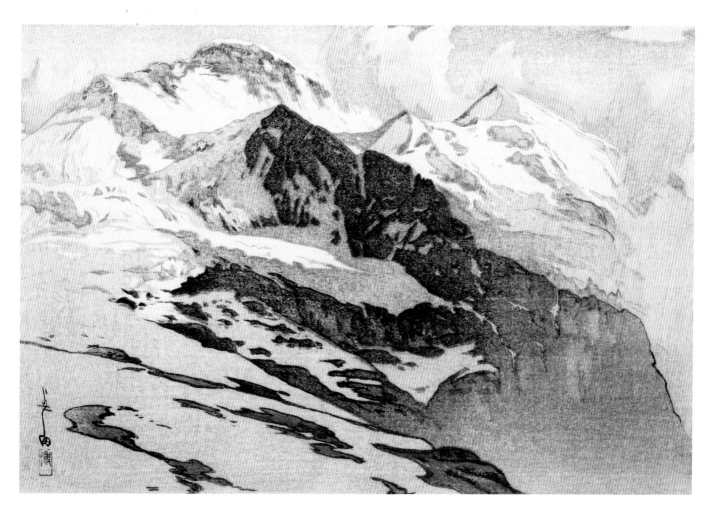

**Yoshida Hiroshi (1876–1950)**
*The Jungfrau,* 1925
Extremely rare final woodblock
proof of the artist
Gift of George and Lola Kidd
AGGV 2003.017.001
Provenance: Yoshida family

*Bottom left:*
**Yoshida Hiroshi (1876–1950)**
*A Canal in Venice,* 1925
Woodcut on paper
Gift of George and Lola Kidd
AGGV 96.20.3

*Bottom right:*
**Yoshida Hiroshi (1876–1950)**
*The Matterhorn, Day,* 1925
Woodcut on paper
Gift of George and Lola Kidd
AGGV 2004.001.002

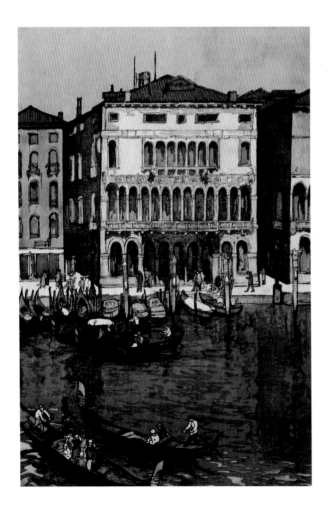

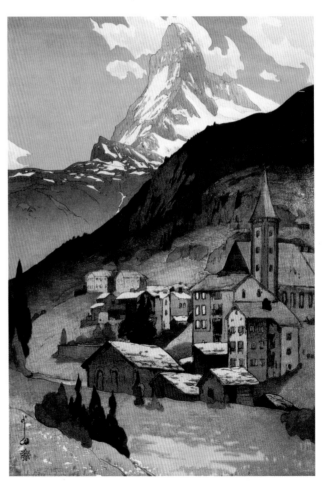

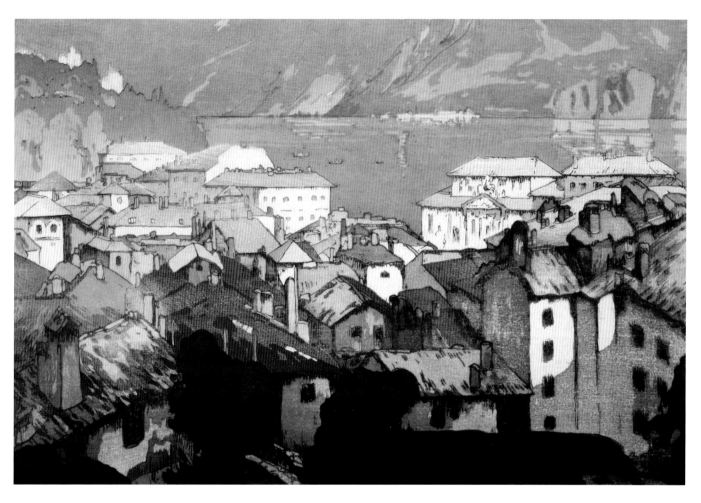

**Yoshida Hiroshi (1876–1950)**
*The Town of Lugano,* 1925
Woodcut on paper
Gift of George and Lola Kidd
AGGV 97.38

*Top:*
**Yoshida Hiroshi (1876–1950)**
*The Acropolis Ruins, Morning,* 1925
Woodcut on woven paper
Gift of George and Lola Kidd
AGGV 96.20.4

*Bottom:*
**Yoshida Hiroshi (1876–1950)**
*The Acropolis Ruins, Night,* 1925
Woodcut on woven paper
Gift of George and Lola Kidd
AGGV 98.38

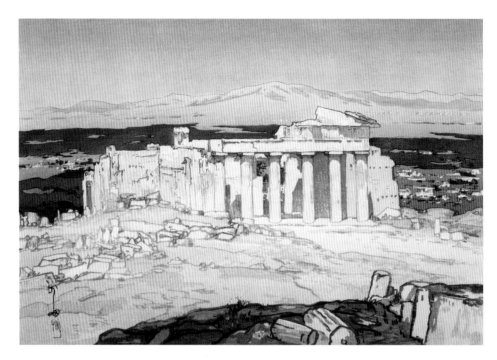

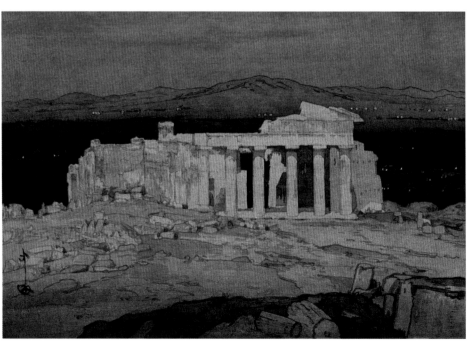

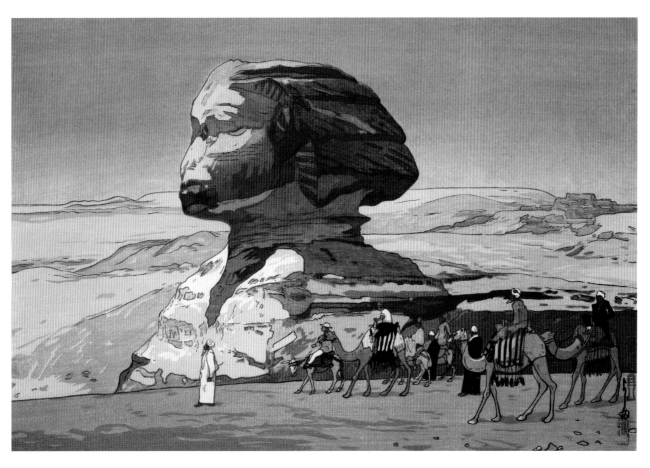

**Yoshida Hiroshi (1876–1950)**
*The Sphinx by Day,* 1925
Woodcut on paper
Gift of George and Lola Kidd
AGGV 2002.025.002

**Yoshida Hiroshi (1876–1950)**
*Tsurugizan, Morning,* 1926
Woodcut on paper
Senora Ryan Estate
AGGV 91.52.39

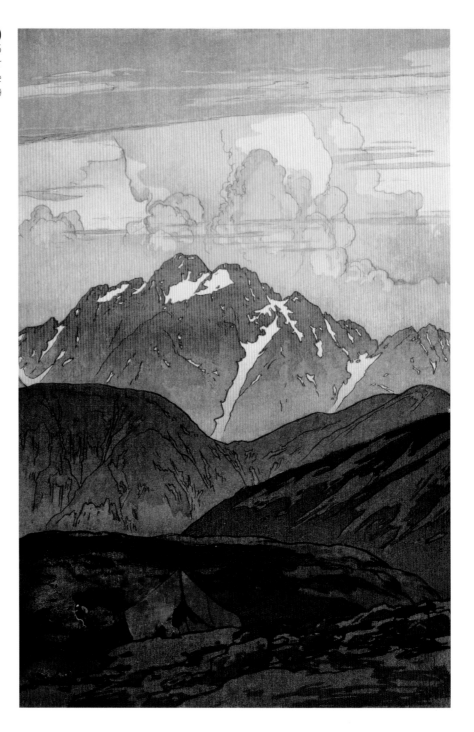

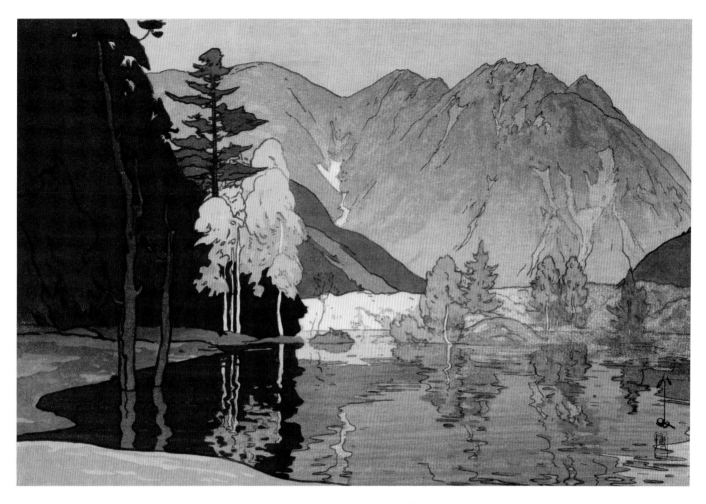

**Yoshida Hiroshi (1876–1950)**
*Hodakadake,* 1926
Woodcut on paper
Gift of Elizabeth Marsters
AGGV 94.13.16

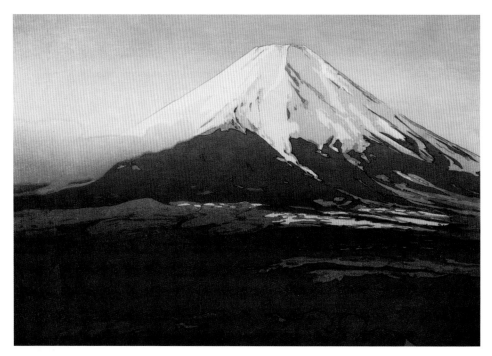

*Top:*
**Yoshida Hiroshi (1876–1950)**
*Fuji from Yoshida,* 1926
Woodcut on paper
Senora Ryan Estate
AGGV 91.52.43

*Bottom:*
**Yoshida Hiroshi (1876–1950)**
*Fuji from Okitsu,* 1928
Woodcut on paper
Gift of Elizabeth Marsters
AGGV 94.13.18

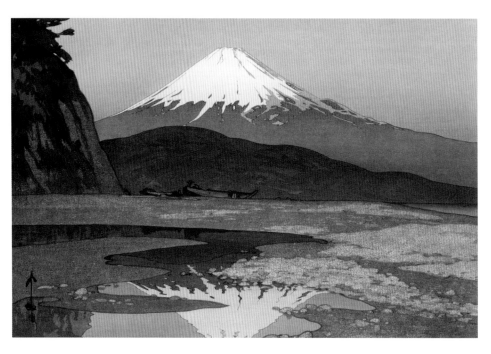

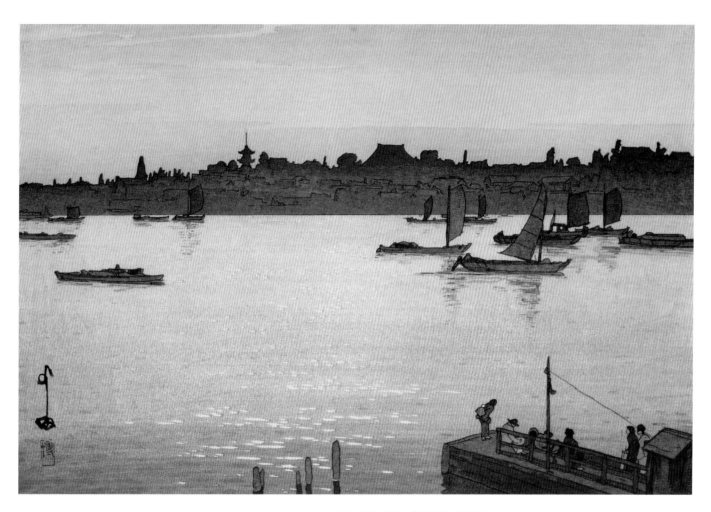

**Yoshida Hiroshi (1876–1950)**
*Sumida River, Afternoon,* 1926
Woodcut on paper
Senora Ryan Estate
AGGV 91.52.42

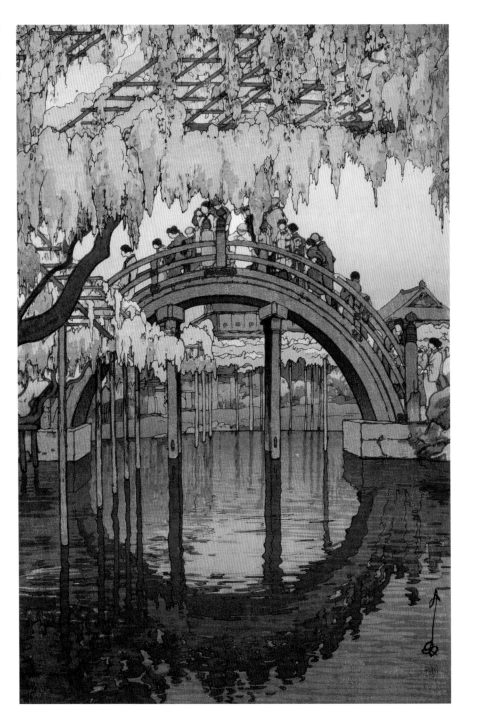

**Yoshida Hiroshi (1876–1950)**
*Kameido Bridge,* 1927
Woodcut on paper
Senora Ryan Estate
AGGV 91.52.37

Shin Hanga, The New Print Movement of Japan

44

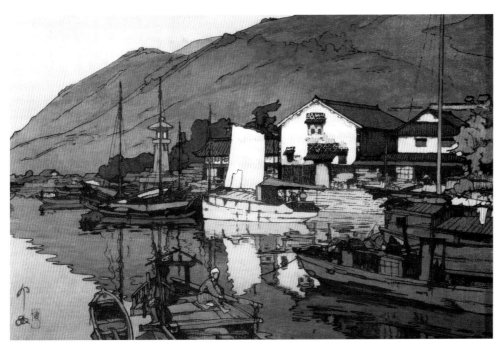

*Top:*
**Yoshida Hiroshi (1876–1950)**
*Harbor of Tomonoura,* 1930
Woodcut on paper
Estate of Eleanor Hardie
AGGV 91.35.2

*Bottom:*
**Yoshida Hiroshi (1876–1950)**
*Tomonoura Godowns,* 1930
Woodcut on paper
Gift of George and Lola Kidd
AGGV 2002.025.001

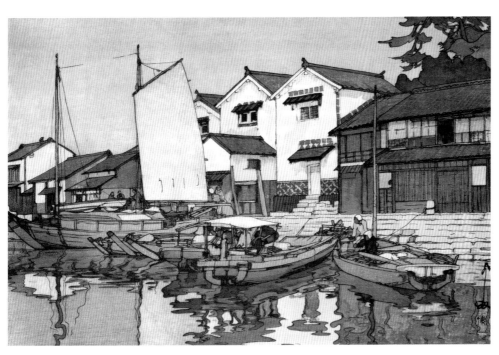

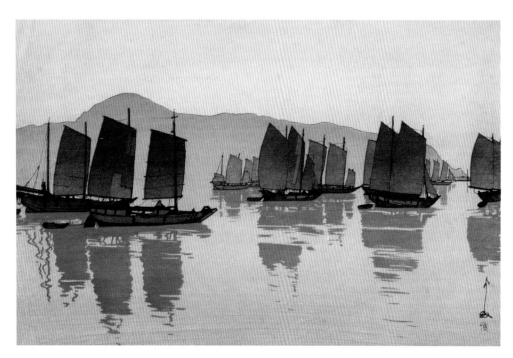

*Top:*
**Yoshida Hiroshi (1876–1950)**
*Abuto in the Morning,* 1930
Woodcut on paper
Gift of Mr. and Mrs. James Langley
AGGV 2004.026.064

*Bottom:*
**Yoshida Hiroshi (1876–1950)**
*Waiting for the Tide,* 1930
Woodcut on paper
Gift of Elizabeth Marsters
AGGV 94.13.17

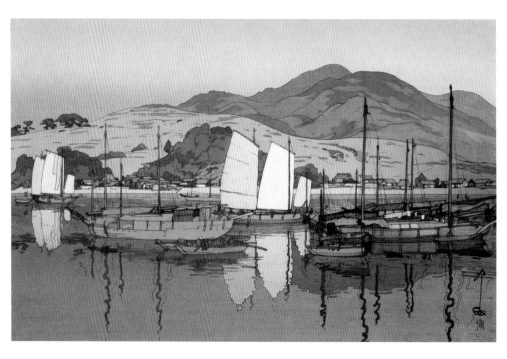

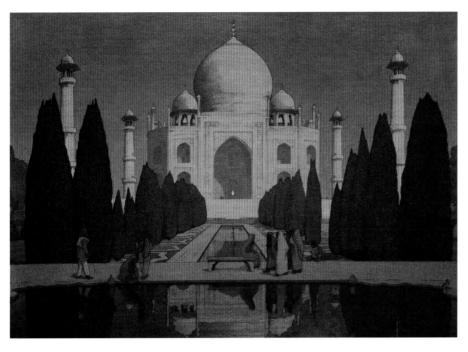

Top:
**Yoshida Hiroshi (1876–1950)**
*Taj Mahal, Night,* 1932
Woodcut on paper
Fred & Isabel Pollard Collection
AGGV 68.211

Bottom:
**Yoshida Hiroshi (1876–1950)**
*Caravan in Afghanistan,* 1932
Woodcut on woven paper
Given in memory of
Mrs. Theo Wiggan by her
ikebana students and friends
AGGV 2004.036.001

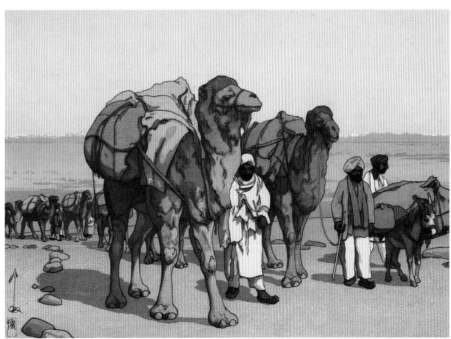

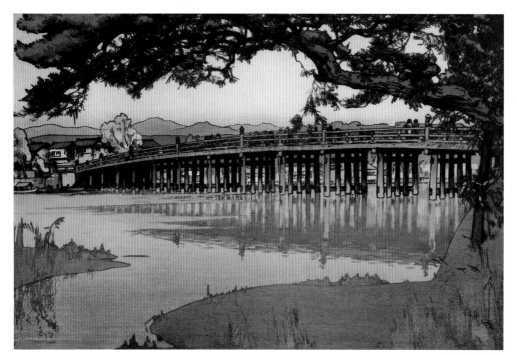

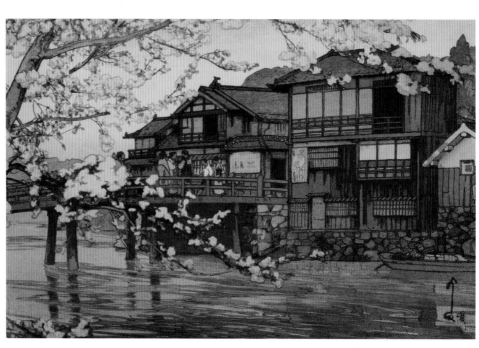

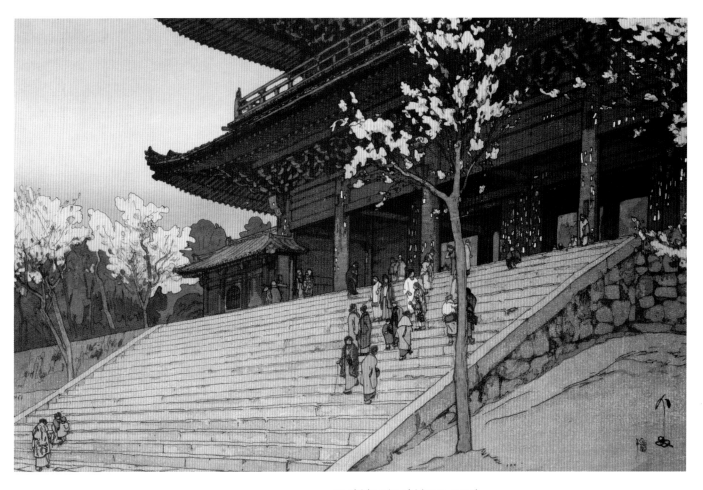

**Yoshida Hiroshi (1876–1950)**
*Chion-in Temple Gate,* 1935
Woodcut on paper
Anonymous gift
AGGV 65.54.1

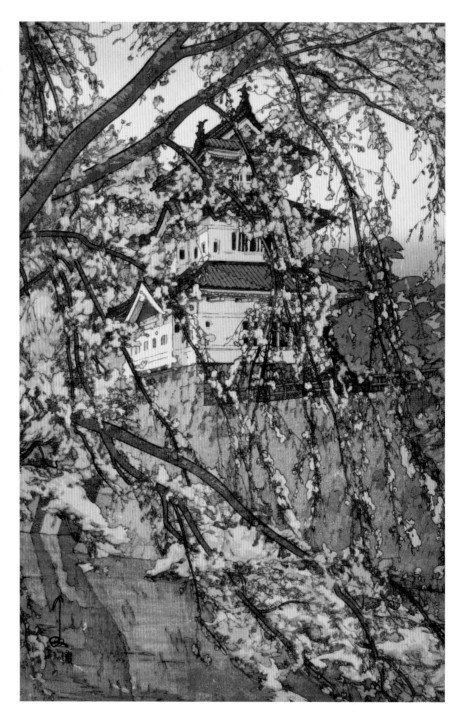

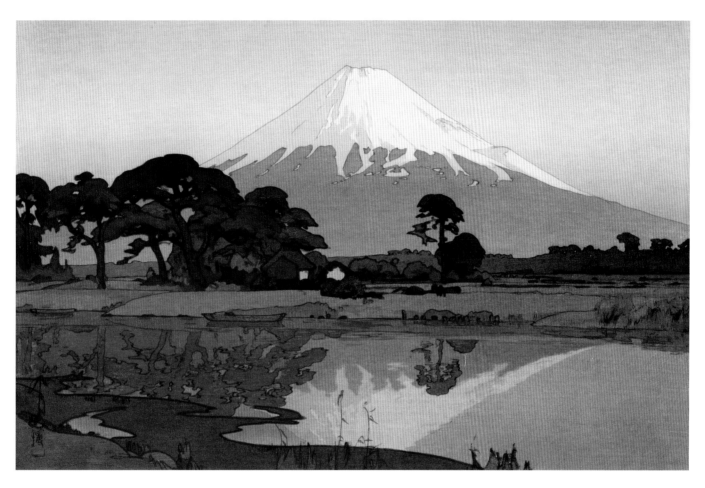

**Yoshida Hiroshi (1876–1950)**
*Suzukawa,* 1935
Woodcut on paper
Gift of Elizabeth Marsters
AGGV 94.13.15

**Yoshida Hiroshi (1876–1950)**
*Cryptomeria Avenue,* 1937
Woodcut on paper
Gift of Elizabeth Marsters
AGGV 94.13.14

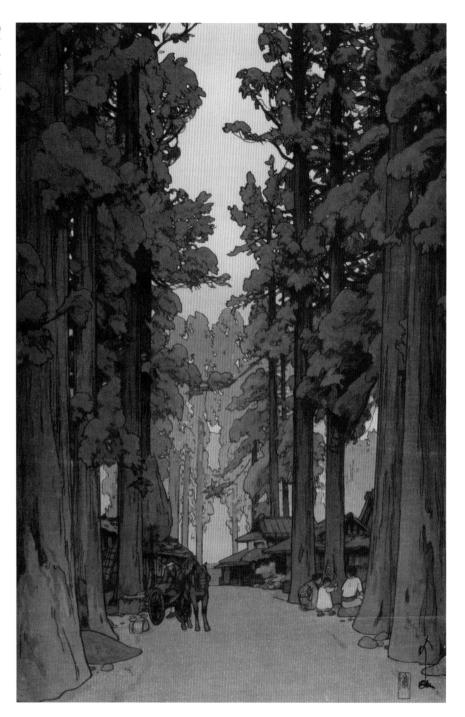

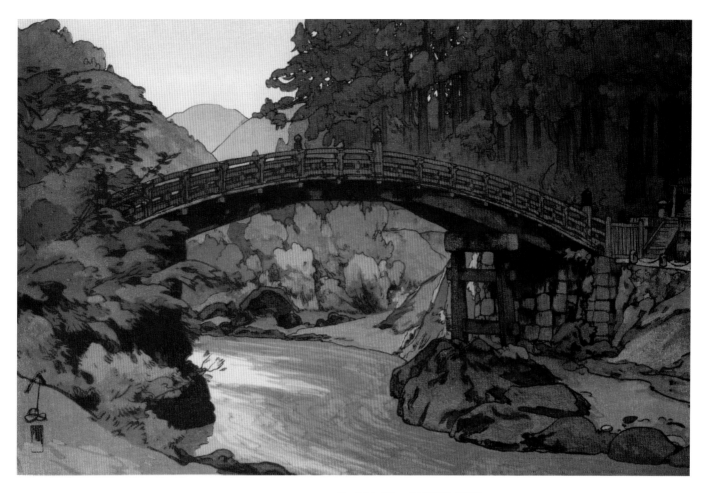

**Yoshida Hiroshi (1876–1950)**
*Sacred Bridge,* 1937
Woodcut on paper
Gift of Elizabeth Marsters
AGGV 94.13.19

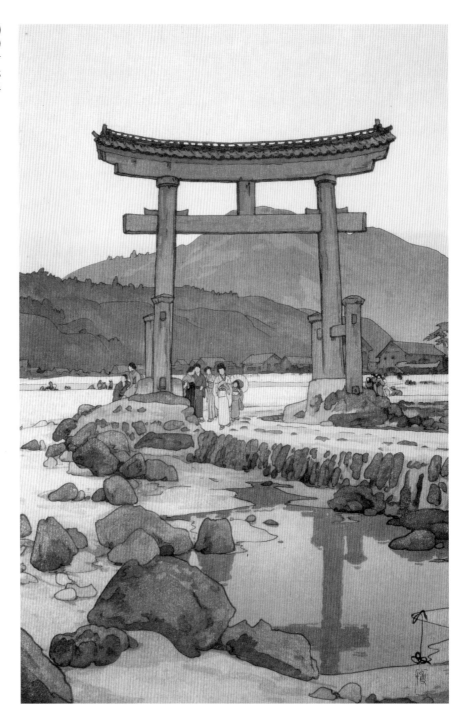

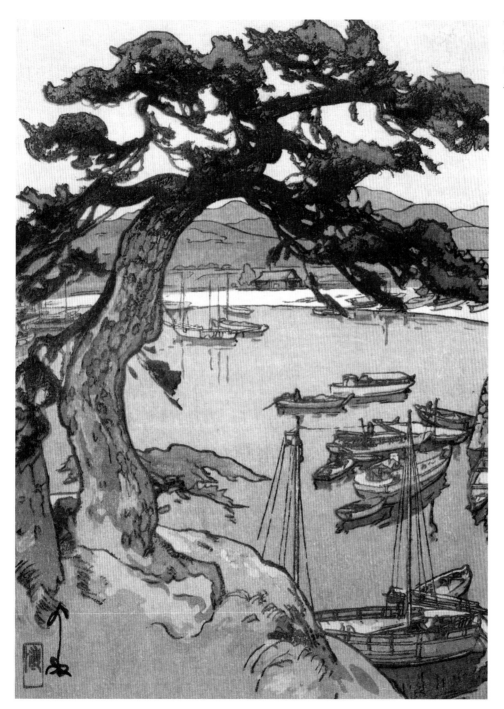

**Yoshida Hiroshi (1876–1950)**
*Little Harbor,* 1941
Woodcut on paper
Gift of George and Lola Kidd
AGGV 2004.001.007

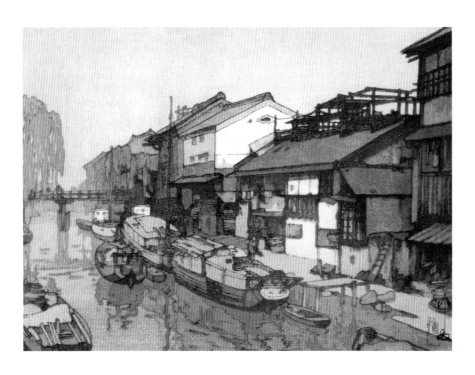

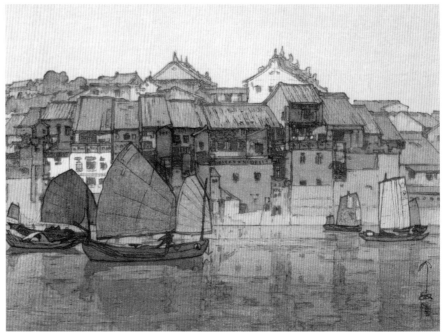

*Top:*
**Yoshida Hiroshi (1876–1950)**
*Canal in Osaka,* 1941
Woodcut on paper
Gift of George and Lola Kidd
AGGV 2004.001.006

*Bottom:*
**Yoshida Hiroshi (1876–1950)**
*Tansui,* 1941
Woodcut on paper
Gift of George and Lola Kidd
AGGV 2004.001.005

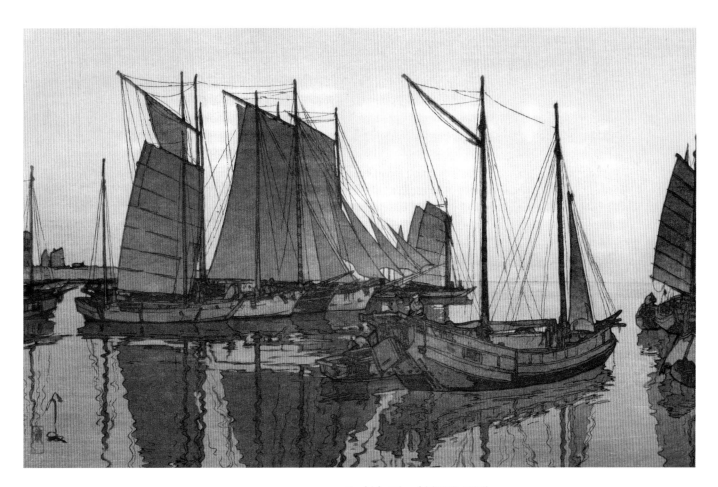

**Yoshida Hiroshi (1876–1950)**
*New Moon,* 1941
Woodcut on paper
Estate of Eleanor Hardie
AGGV 91.35.1

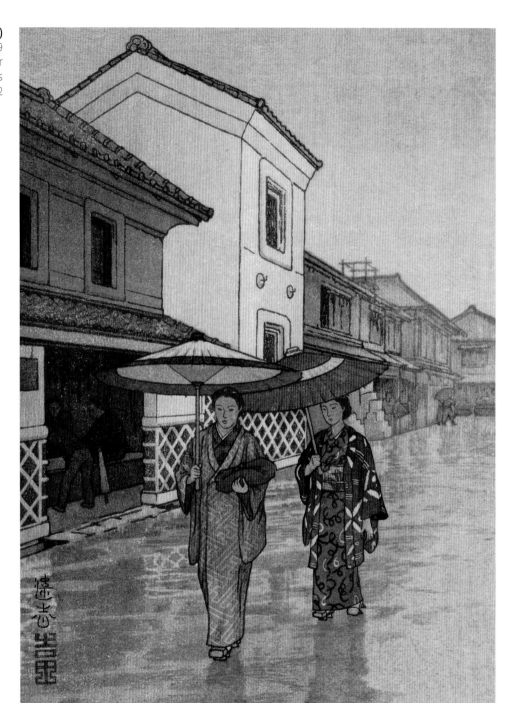

**Yoshida Toshi (1911–1995)**
*Umbrella,* 1939
Woodcut on paper
Gift of Elizabeth Marsters
AGGV 94.13.12

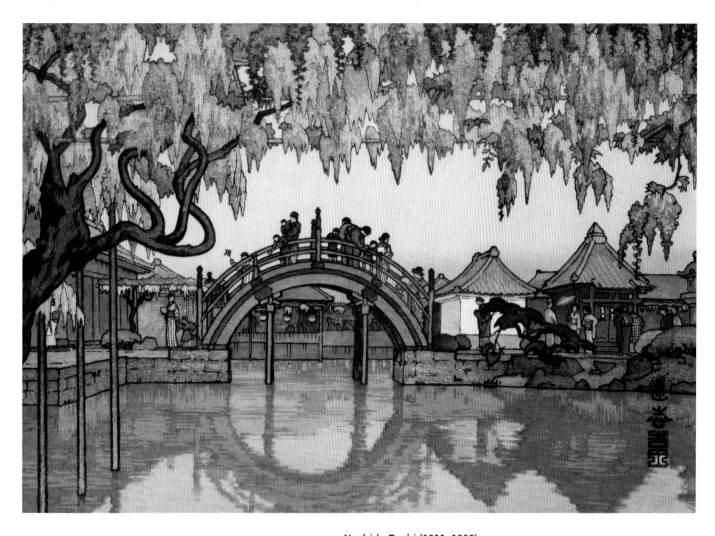

**Yoshida Toshi (1911–1995)**
*Half Moon Bridge,* 1940
Woodcut on paper
Gift of Elizabeth Marsters
AGGV 94.13.6

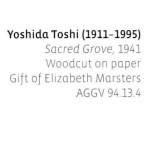

**Yoshida Toshi (1911–1995)**
*Sacred Grove,* 1941
Woodcut on paper
Gift of Elizabeth Marsters
AGGV 94.13.4

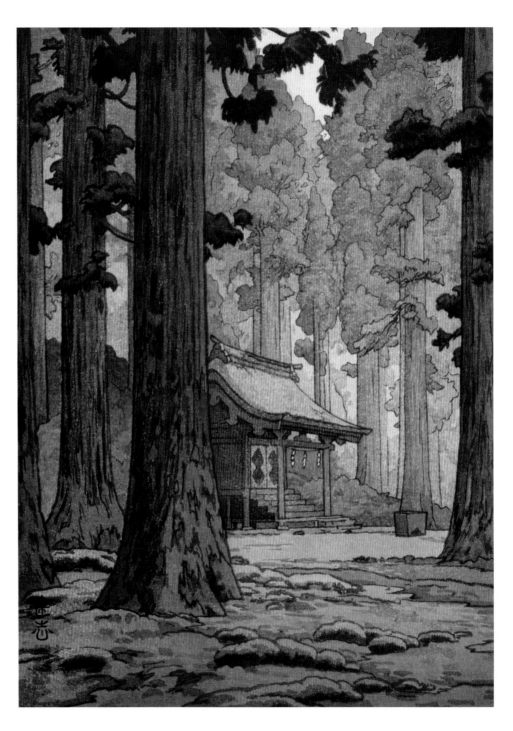

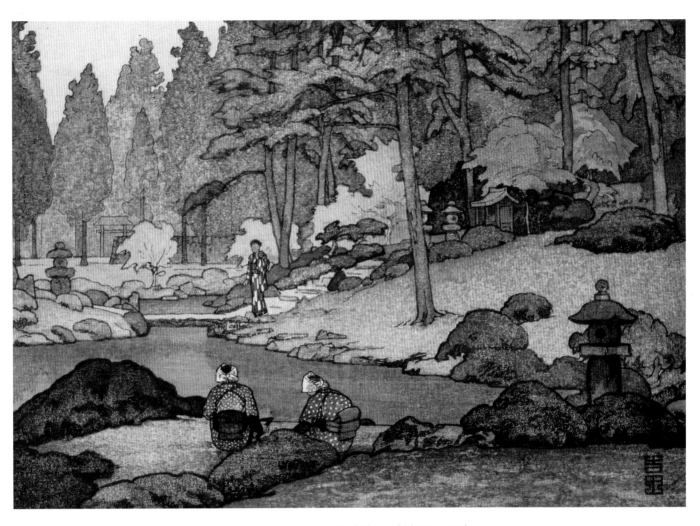

**Yoshida Toshi (1911–1995)**
*Linnoji Garden,* 1941
Woodcut on paper
Gift of Elizabeth Marsters
AGGV 94.13.1

**Yoshida Toshi (1911–1995)**
*Tenryo River,* 1942
Woodcut on paper
Gift of Elizabeth Marsters
AGGV 94.13.2

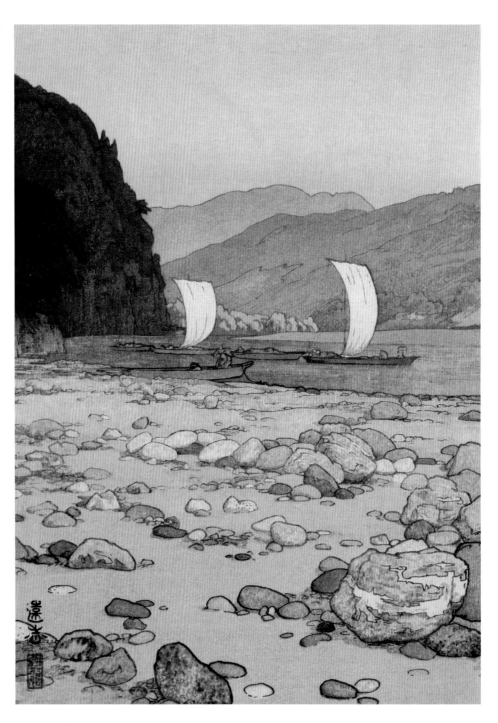

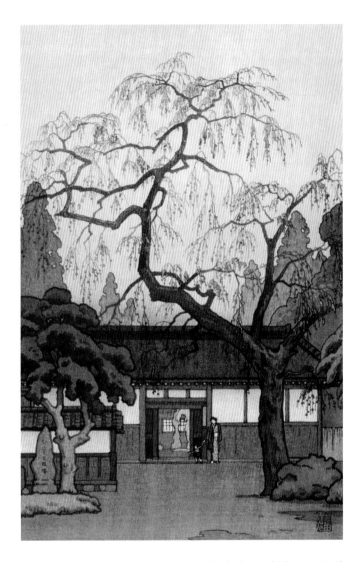

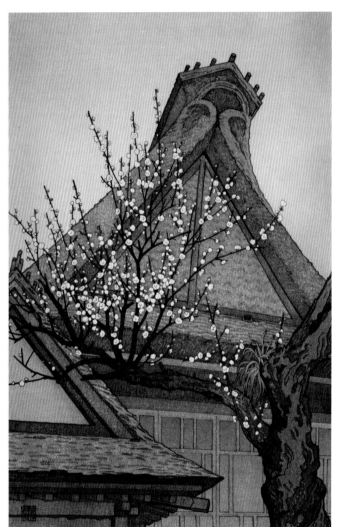

**Yoshida Toshi (1911–1995)**
*Cherry Blossoms by the Gate,* 1951
Woodcut on paper
Gift of Elizabeth Marsters
AGGV 94.13.9

**Yoshida Toshi (1911–1995)**
*White Plum in the Farmyard,* 1951
Woodcut on paper
Gift of Elizabeth Marsters
AGGV 94.13.11

**Yoshida Toshi (1911–1995)**
*Peggy's Cove,* 1975
Woodcut on paper
Gift of Betty Demic, Winnipeg
AGGV 99.282

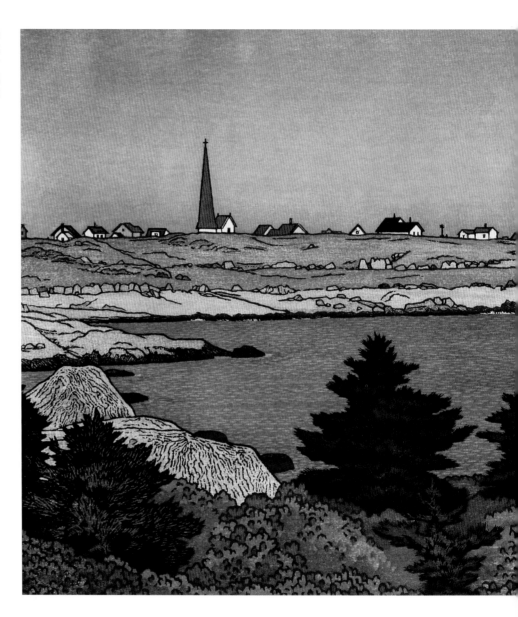

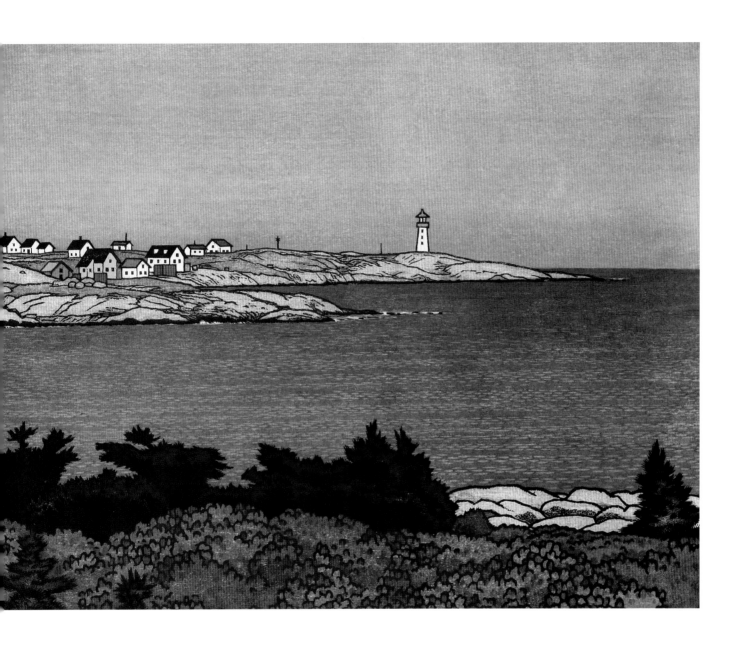

Shin Hanga, The New Print Movement of Japan

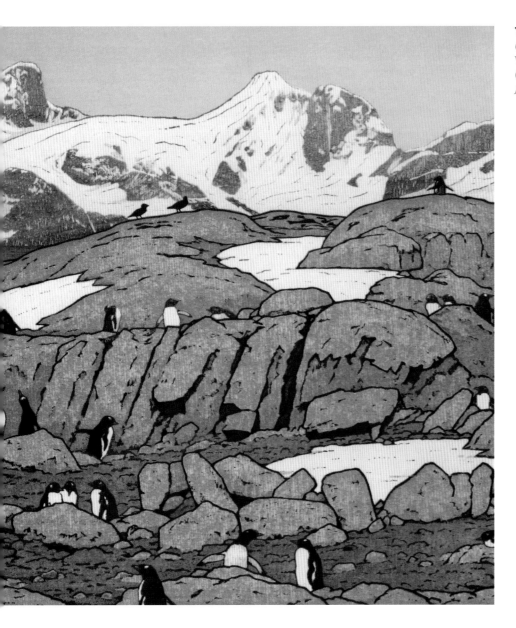

**Yoshida Toshi (1911–1995)**
*Gentoo Penguins,* 1977
Woodcut on paper
Gift of George and Lola Kidd
AGGV 2003.025.001

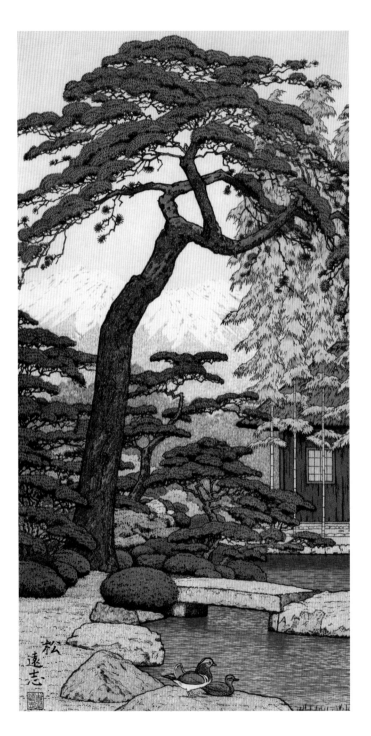

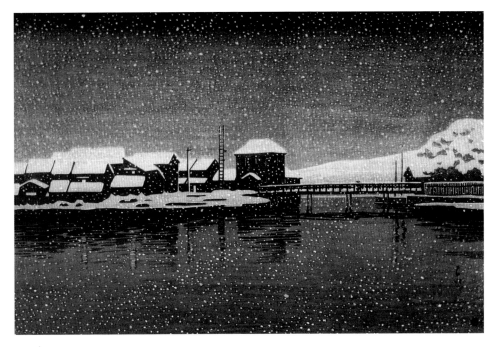

*Top:*
**Kawase Hasui (1883–1957)**
*Night Rainfall on Bridge,*
1921
Woodcut on paper
Senora Ryan Estate
AGGV 91.52.48

*Bottom:*
**Kawase Hasui (1883–1957)**
*Seven Miles from Nakayama in Hida District,* 1924
Woodcut on paper
Senora Ryan Estate
AGGV 91.52.49

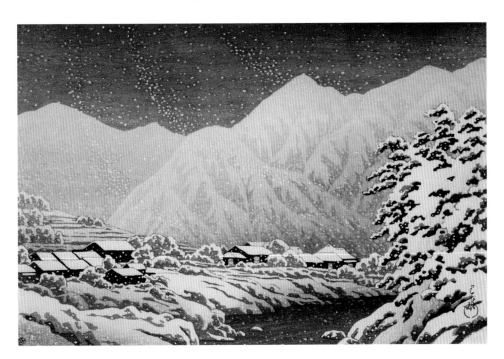

**Kawase Hasui (1883–1957)**
*Takatsu in Osaka,* 1924
Woodcut on paper
Senora Ryan Estate
AGGV 91.52.50

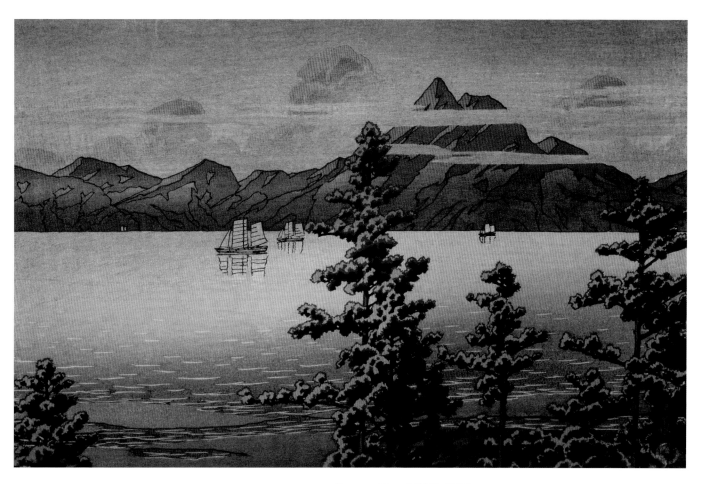

**Kawase Hasui (1883–1957)**
*Unsen Peak, Hizen,* 1926
Woodcut on paper
Senora Ryan Estate
AGGV 91.52.26

**Kawase Hasui (1883–1957)**
*Mount Fuji Clear After Snow
from Takaonoura,* 1932
Woodcut on paper
Gift of Elizabeth Marsters
AGGV 94.13.21

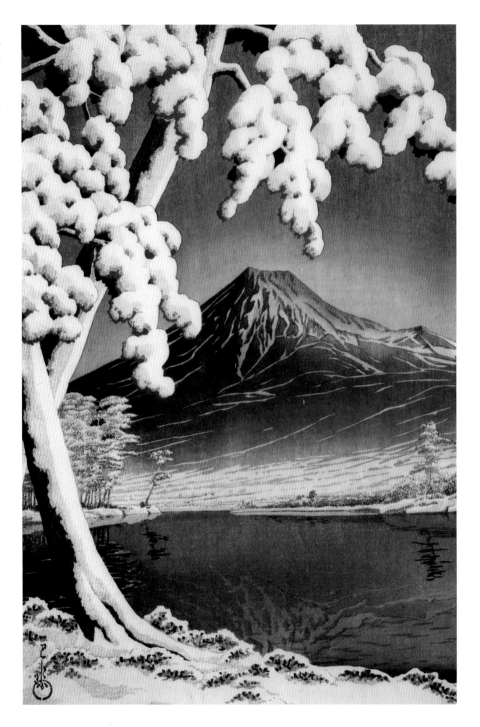

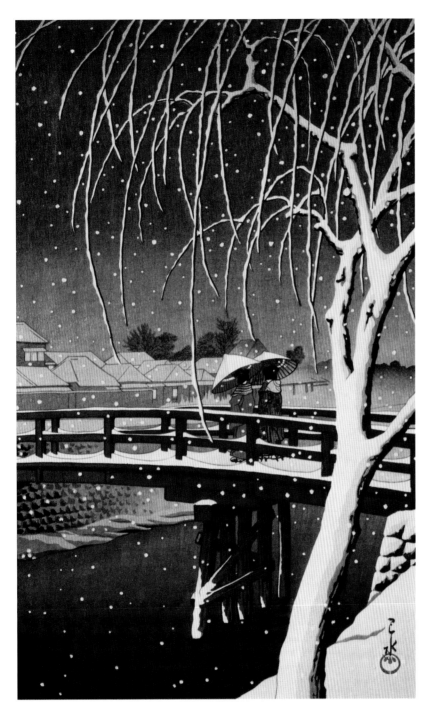

**Kawase Hasui (1883–1957)**
*Late Snow Along Edo River,* 1932
Woodcut on paper
Gift of Elizabeth Marsters
AGGV 94.13.20

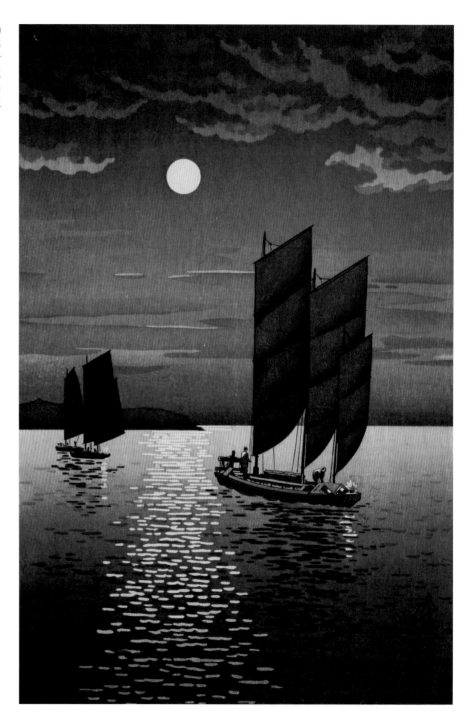

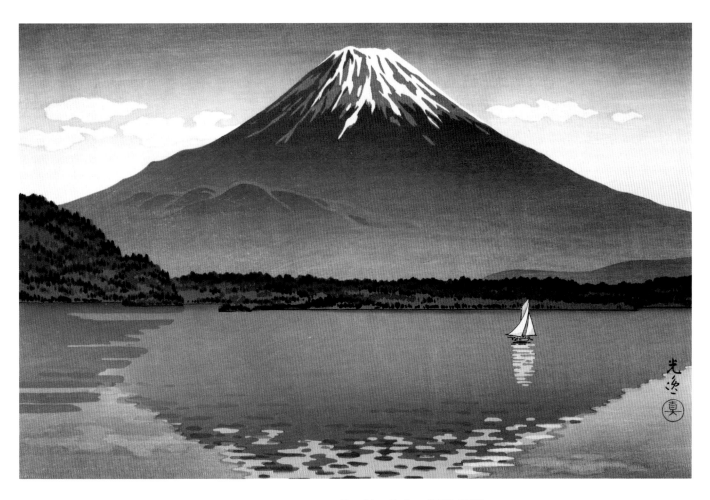

**Tsuchiya Koitsu (1870–1949)**
*Mount Fuji,* 1934
Woodcut on paper
Gift of Elizabeth Marsters
AGGV 94.13.26

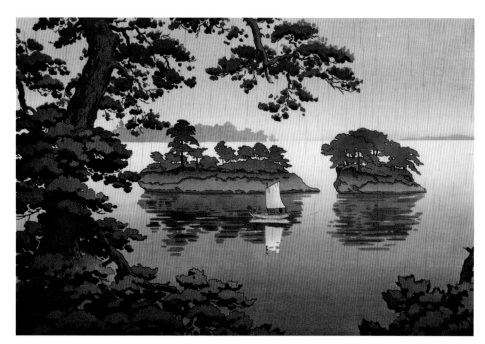

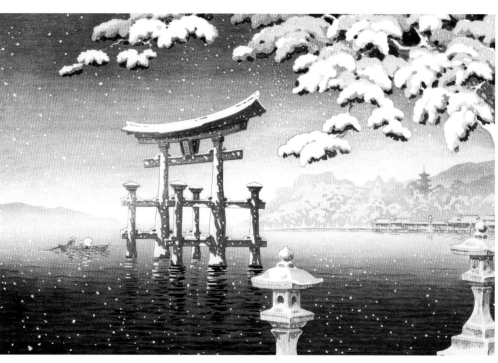

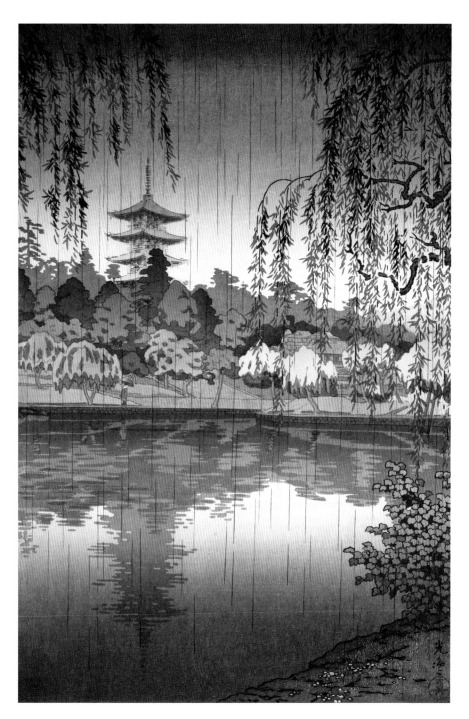

**Tsuchiya Koitsu (1870–1949)**
*Nara Kofuku Temple,* 1937
Woodcut on paper
Gift of Elizabeth Marsters
AGGV 94.13.27

**Tsuchiya Koitsu (1870–1949)**
*Hakone Lake,* 1938
Woodcut on paper
Gift of Elizabeth Marsters
AGGV 94.13.25

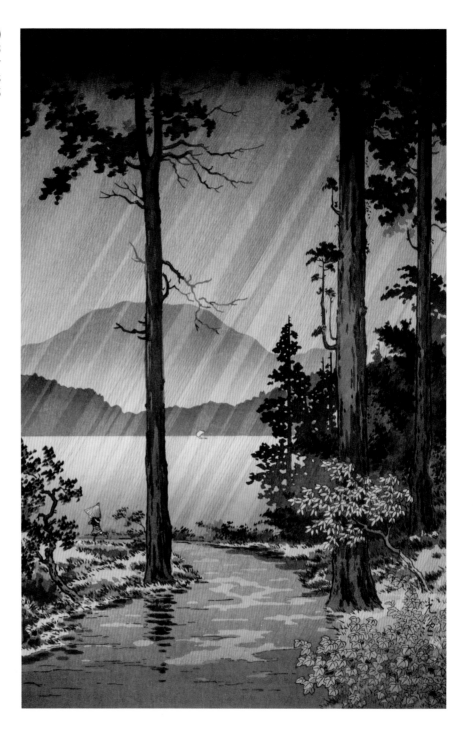

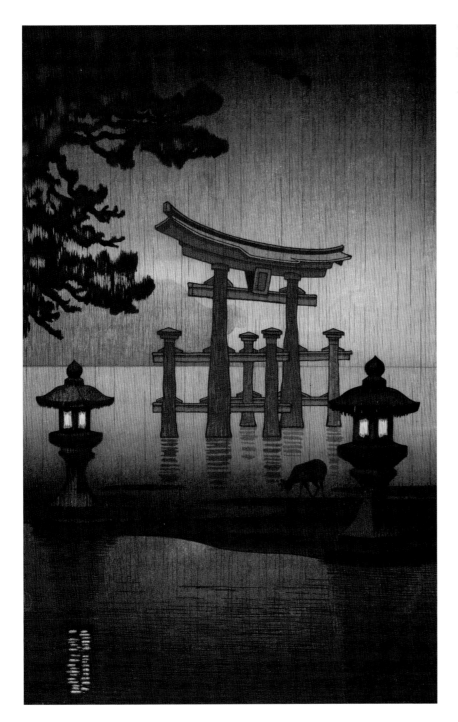

**Tsuchiya Koitsu (1870–1949)**
*Miyajima in the Rain,* 1941
Woodcut on paper
Gift of Elizabeth Marsters
AGGV 94.13.23

**Kasamatsu Shiro (1898–1991)**
*Evening Rain, Yanaka Pagoda,*
*Tokyo,* 1932
Woodcut on paper
Given in memory of Suga Mutsu
by her husband, Ian Mutsu
AGGV 85.31

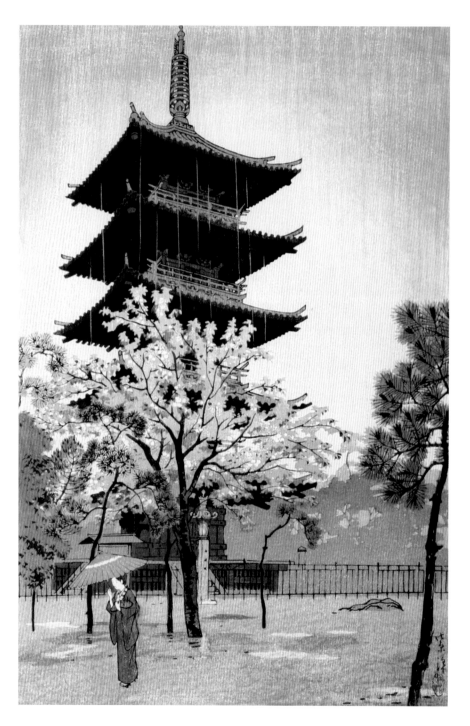

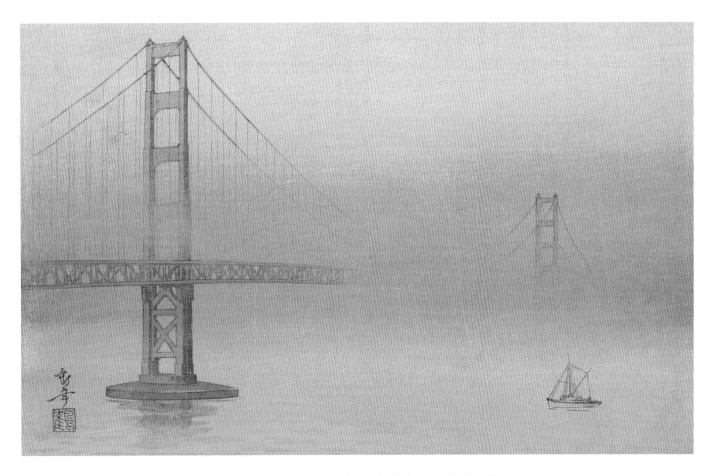

**Tsuruoka Kakunen (1892–1977)**
*Golden Gate Bridge,* 1936
Woodcut on paper
Gift of Mr. and Mrs. William Hepler
AGGV 92.39.6

**Toko (active 1930s)**
*Moon over Tide at Enoshima,* 1933
Woodcut on paper
Gift of Elizabeth Marsters
AGGV 94.13.28

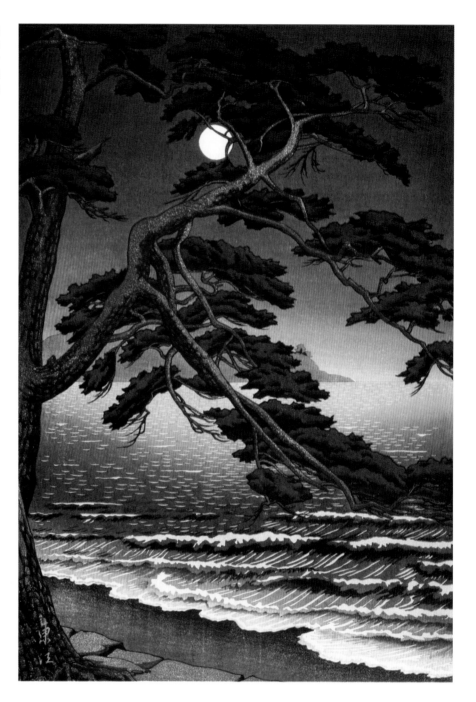

*Top:*
**Yamada Basuke**
**(active mid–1930s)**
*Painter by Ferry Boat,* c. 1930
Woodcut on paper
Senora Ryan Estate
AGGV 91.52.25

*Bottom:*
**Nomura Yoshimitsu**
**(active 1920s–1930s)**
*Fushimi Imari Shrine,* 1931
Woodcut on paper
Robin Bourne Fund
AGGV 94.64

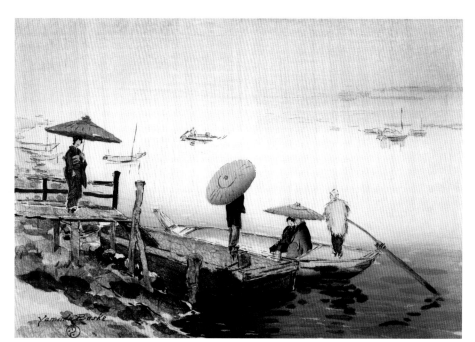

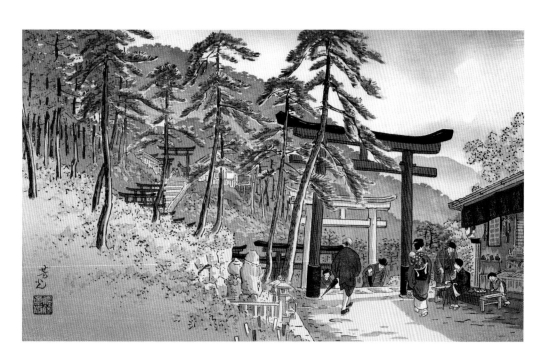

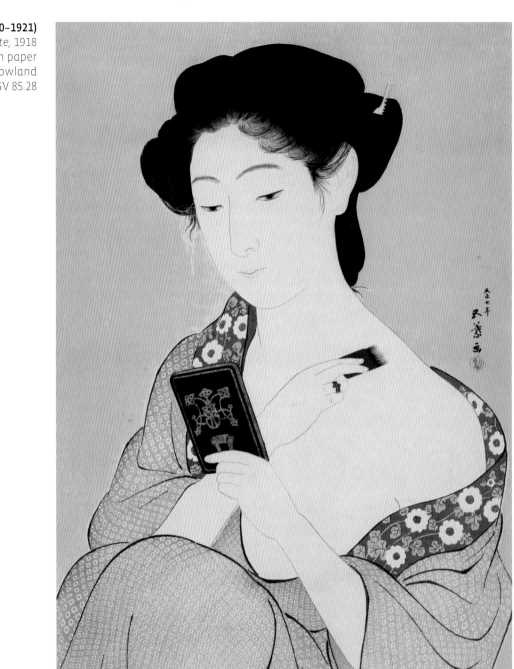

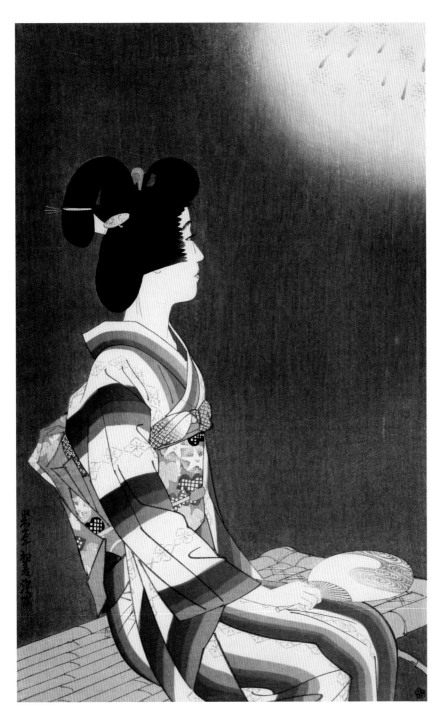

**Ito Shinsui (1898–1972)**
*Fireworks,* 1934
Woodcut on paper
Fred & Isabel Pollard Collection
AGGV 73.244

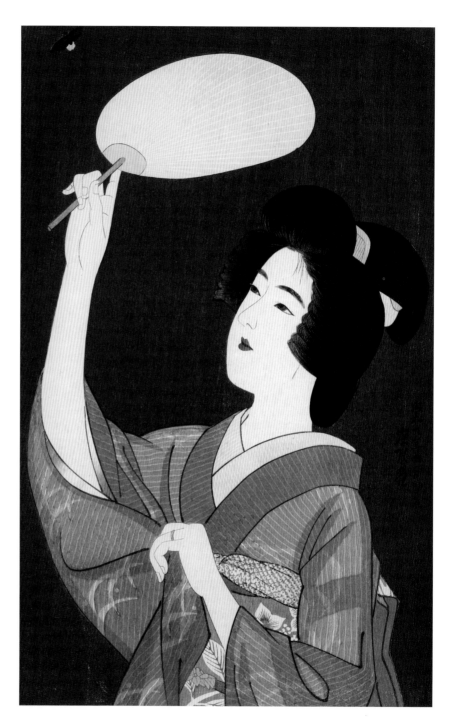

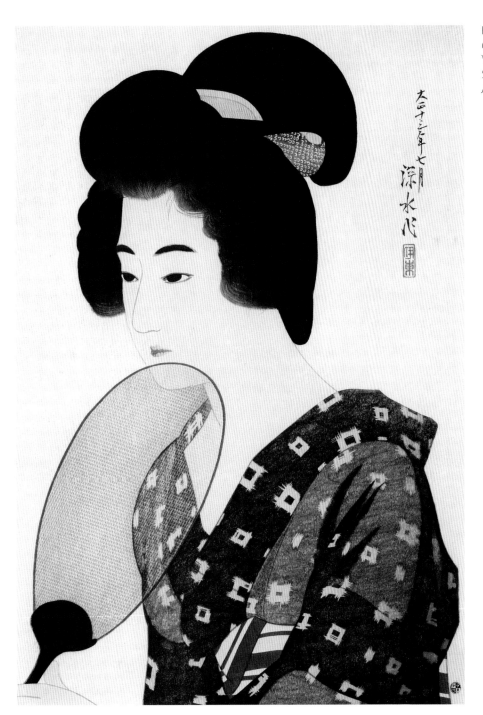

**Ito Shinsui (1898–1972)**
*Girl with a Fan,* 1924
Woodcut on paper
Senora Ryan Estate
AGGV 91.52.36

**Kobayakawa Kiyoshi (1896–1948)**
*The Geisha, Ichimaru,* 1933
Woodcut on paper
Given in memory of
Mrs. Theo Wiggan by her
ikebana students and friends
AGGV 2001.019.001

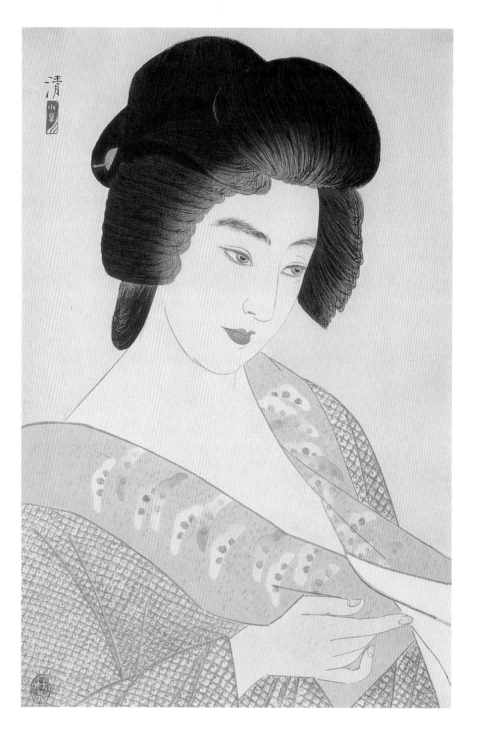

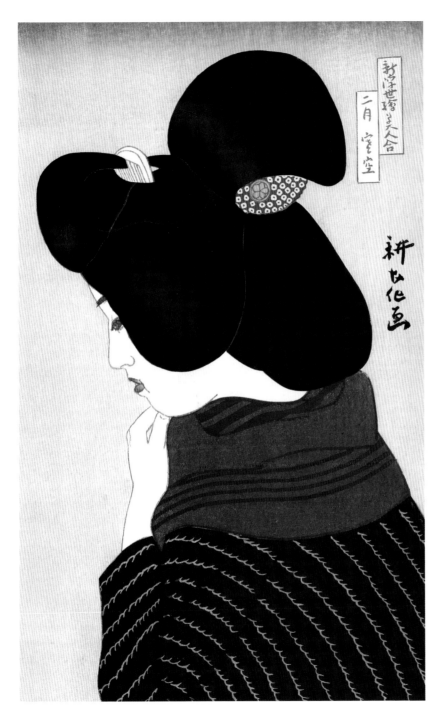

**Yamamura Toyonari (1885–1942)**
*February, Winter Sky*
Series: *Collection of New Ukiyo-e Style Beauties,* 1924
Woodcut on paper
Given in memory of Mrs. Theo Wiggan by her ikebana students and friends
AGGV 2005.021.001

**Shima Seien (1892–1970)**
*After the Bath,* 1932
Woodcut on paper
Esme Davis, Margaret M. Dowell,
and Mrs. Archibald Lietch Funds
AGGV 90.3

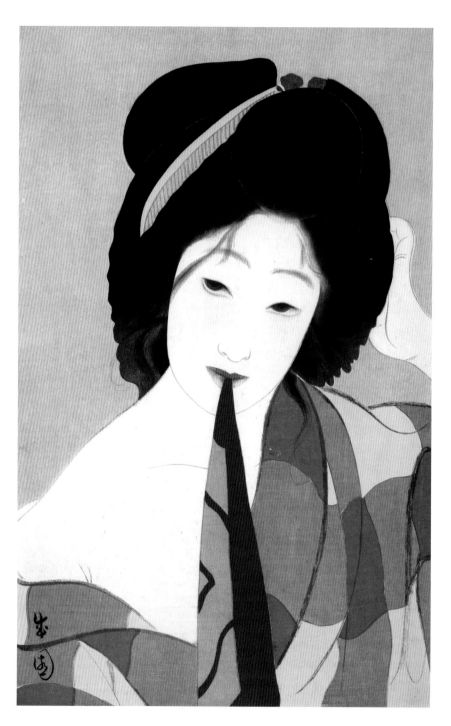

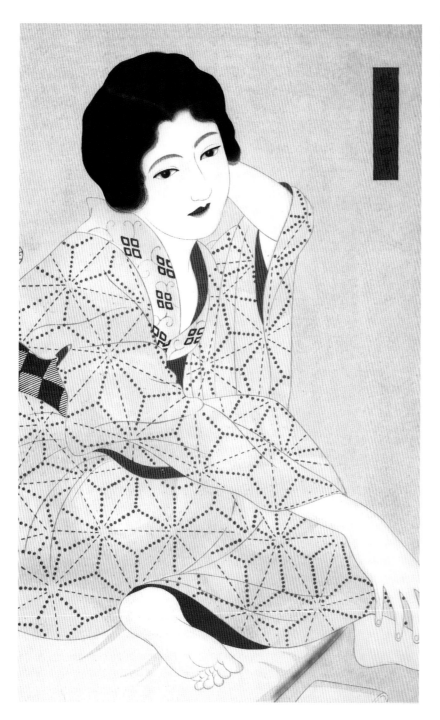

**Ohira Kasen (1900–1983)**
*Seated Woman,* n.d.
Woodcut on paper
Gift of the American Friends of Canada,
through the generosity of
Carol Potter Peckham
AGGV 97.46.4

**Okada Saburosuke
(1869–1939)**
*The Heroine Osan*
Series: *Complete Works of
Chikamatsu,* c. 1923
Woodcut on paper
Given in memory of Jo-Ann
Lajeunesse, who taught us to
appreciate the beauty in all
things, by her daughter, Carrie
Lajeunesse, and family
AGGV 2006.007.007

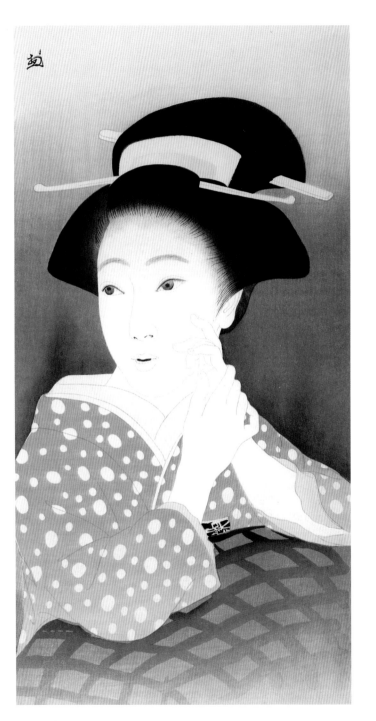

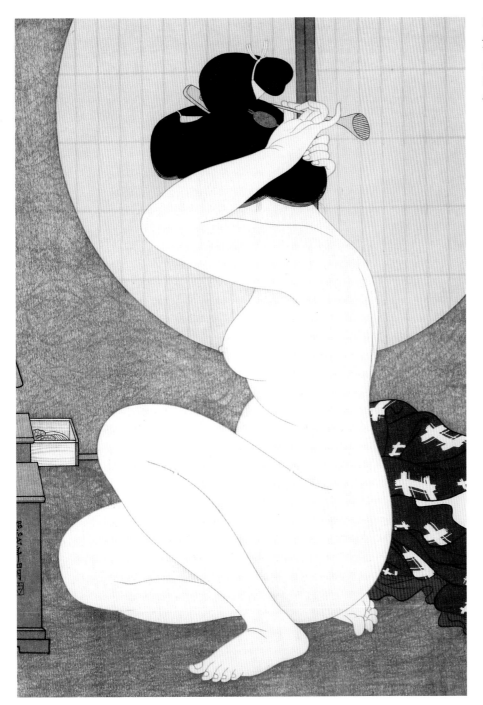

**Hirano Hakuho (1879–1957)**
*Arranging Hair,* 1932
Woodcut on paper
Given in memory of
Hu and Eileen Whiting
AGGV 90.19

**Natori Shunsen (1886–1960)**
*Ichimura Uzaemon XV
as Naoji,* 1925
Woodcut on paper
Given in memory of Suga Matsu
by Mrs. Ruth E. Chisholm
AGGV 85.32

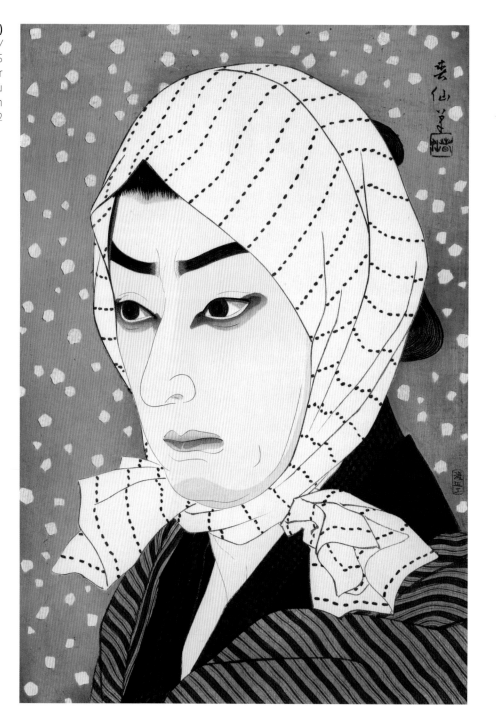

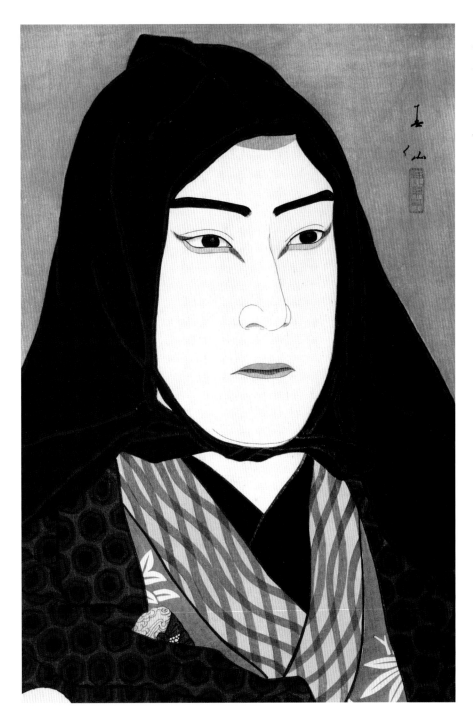

**Natori Shunsen (1886–1960)**
*Onoye Baiko as Sayari,* 1925
Woodcut on paper
Gift of Peter Gellatly in memory
of Peter Gellatly Sr. and
Clara McIntosh Gellatly
AGGV 96.6.24

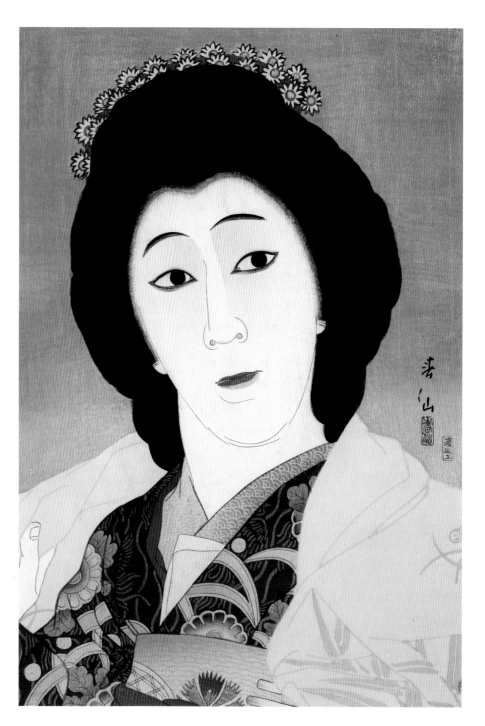

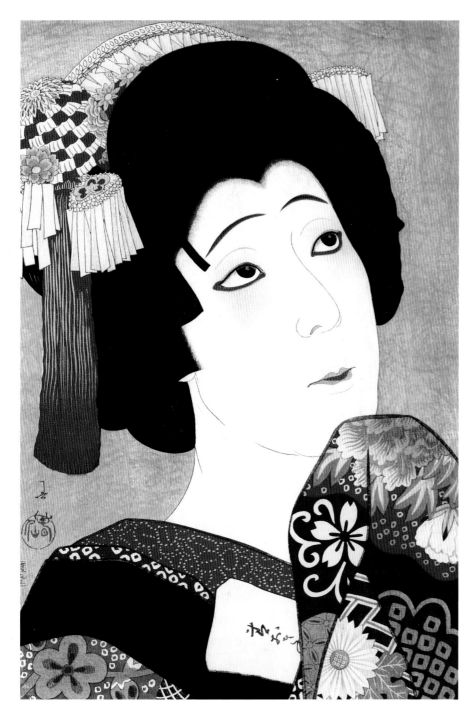

**Natori Shunsen (1886–1960)**
*Nakamura Fukusuje as Ohan,* 1925
Woodcut on paper
Gift of Peter Gellatly in memory of
Peter Gellatly Sr. and
Clara McIntosh Gellatly
AGGV 96.6.23

**Yamamura Toyonari (1885–1942)**
*Bando Mitsugoro VII in the Role of the Mute in the Play "Sannin–Katawa" (Three Disabled Persons)*
Series: *The Flowers of the Theatre,* 1922
Woodcut on paper
Given in memory of Mrs. Theo Wiggan by her ikebana students and friends
AGGV 2005.022.001

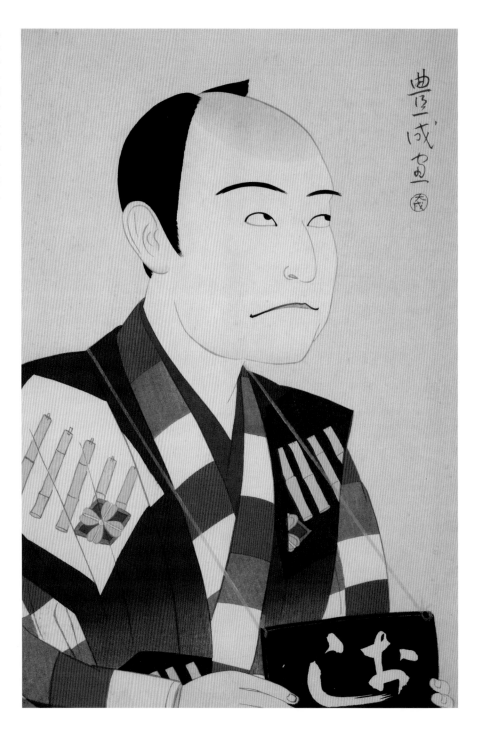

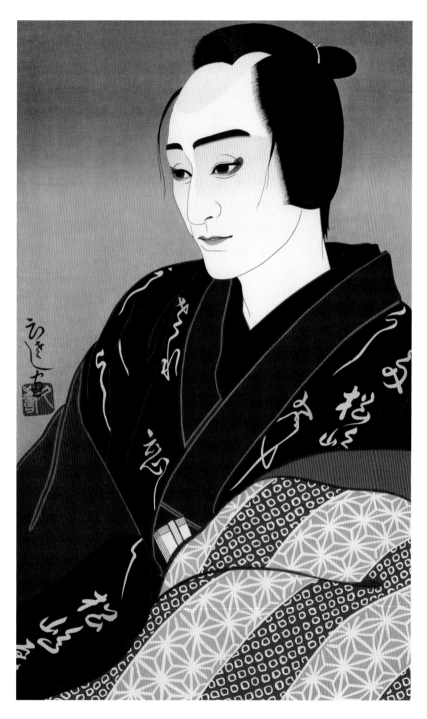

**Yamamoto Hisashi
(active late twentieth century)**
*Kabuki Actor Kataoka Takao (Kataoka
Nizaemon XV) in the Role of Izaemon,* 1981
Woodcut on paper
Gift of Cynthia Field
AGGV

**Nishimura Hodo**
**(active 1930s)**
*Iris,* c. 1939
Woodcut on paper
Senora Ryan Estate
AGGV 91.52.11

**Sugiura Hisui (1876–1965)**
*Morning Glory,* n.d.
Woodcut on paper
Gift of Mr. and Mrs. William Hepler
AGGV 92.44.25

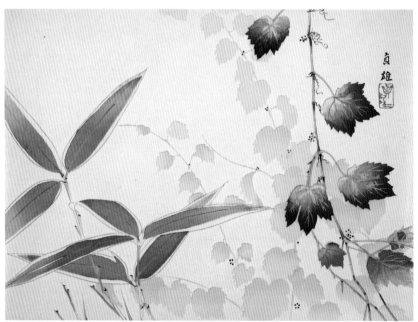

*Top:*
**Konan Tanigami
(active 1910s–1920s)**
*Camellia,* n.d.
Woodcut on paper
Gift of Elizabeth Marsters
AGGV 94.13.30

*Bottom:*
**Sadao (active 1920s–1930s)**
*Boston Ivy and Bamboo,* n.d.
Woodcut on paper
Gift of Mr. and Mrs. William Hepler
AGGV SC711

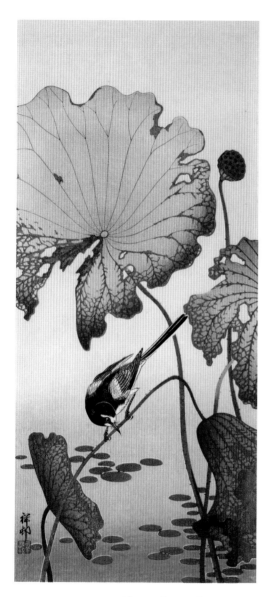

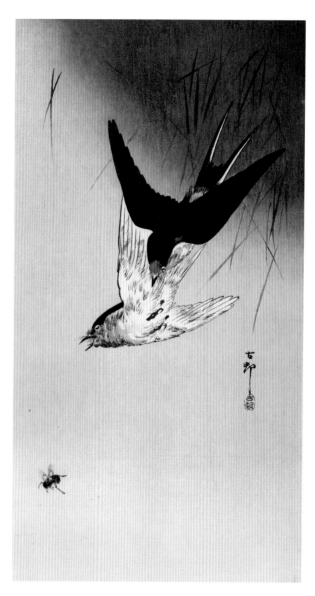

**Ohara Shoson (1877–1945)**
*Wagtail and Lotus,* n.d.
Woodcut on paper
Gift of Mr. and Mrs. William Hepler
AGGV 92.44.2

**Ohara Shoson (1877–1945)**
*Swallows and Bee,* n.d.
Woodcut on paper
Gift of Mr. and Mrs. William Hepler
AGGV 92.44.4

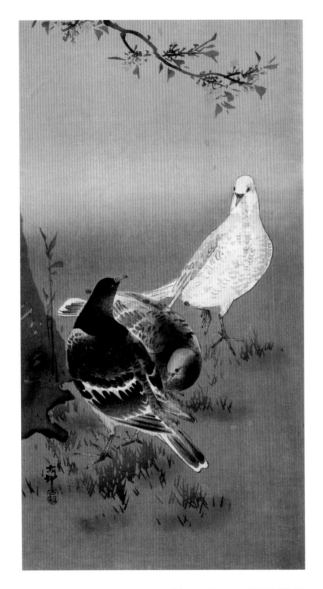

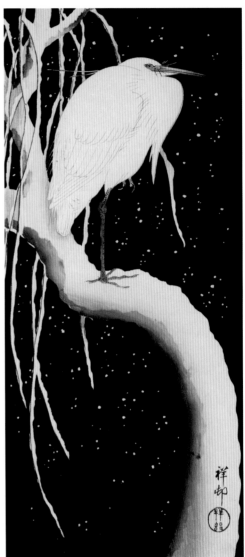

**Ohara Shoson (1877–1945)**
*Pigeons,* n.d.
Woodcut on paper
Gift of Mr. and Mrs. William Hepler
AGGV 92.44.5

**Ohara Shoson (1877–1945)**
*Egret on Snowy Tree,* 1930
Woodcut on paper
Gift of Mr. and Mrs. William Hepler
AGGV 92.44.7

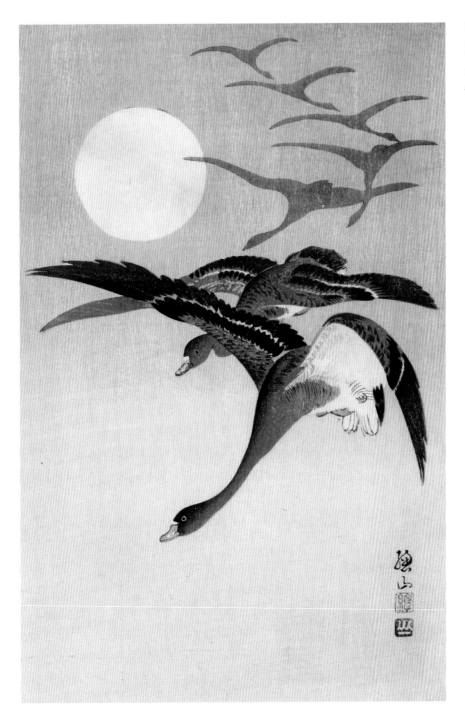

**Ito Sozan (1884–?)**
*Flying Geese and Moon,* n.d.
Woodcut on paper
Gift of Mr. and Mrs. William Hepler
AGGV 92.44.8

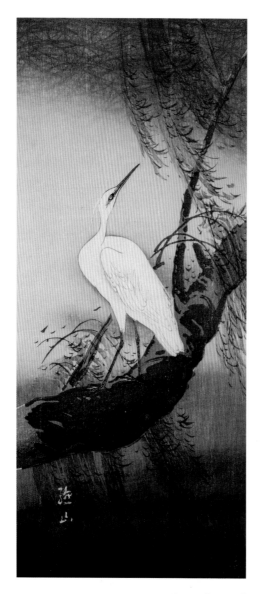

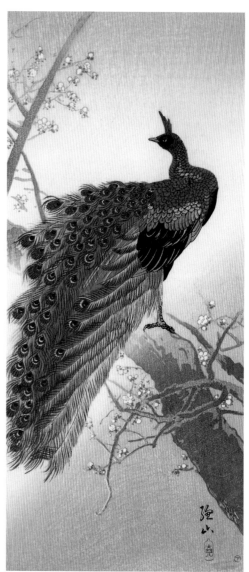

Ito Sozan (1884–?)
*White Egret*, n.d.
Woodcut on paper
Gift of Mr. and Mrs. William Hepler
AGGV SC704

Ito Sozan (1884–?)
*Peacock*, n.d.
Woodcut on paper
Gift of Mr. and Mrs. William Hepler
AGGV SC706

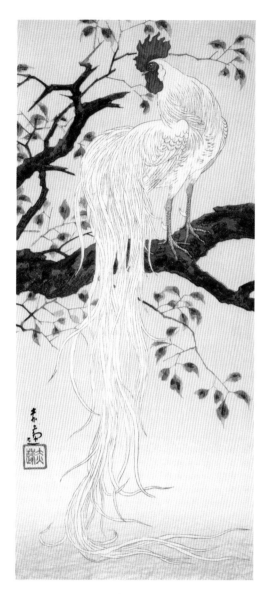

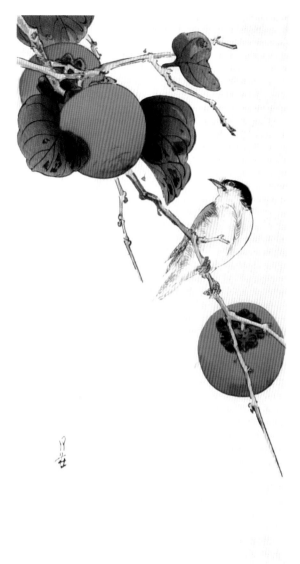

**Sekihen (active 1920s–1930s)**
*Long-tailed Rooster,* n.d.
Woodcut on paper
Gift of Mr. and Mrs. William Hepler
AGGV 92.44.15

**Yoshimoto Gesso (1881–1936)**
*Bird and Persimmons,* n.d.
Woodcut on paper
Gift of Mr. and Mrs. William Hepler
AGGV 92.44.14

**Soseki (active 1920s)**
*Geese in Snow*, n.d.
Woodcut on paper
Gift of Mr. and Mrs. William Hepler
AGGV 92.44.10

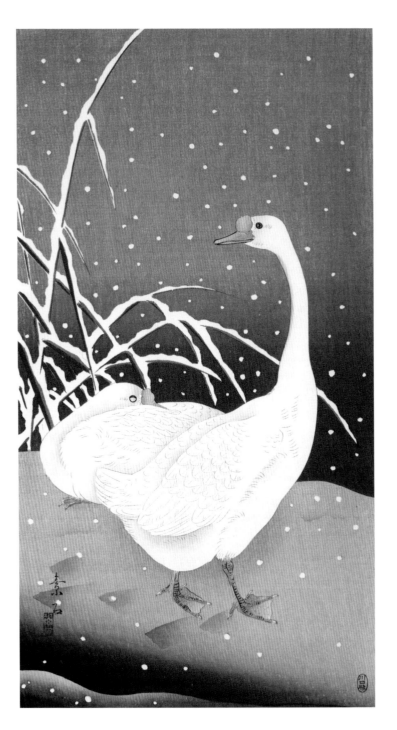

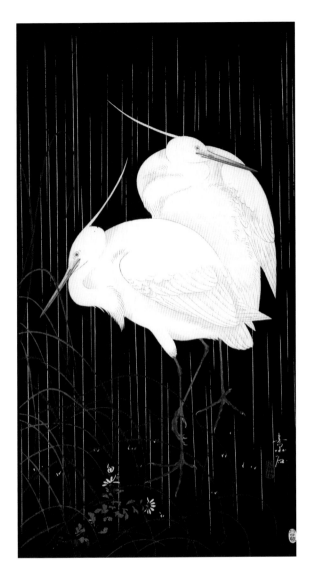

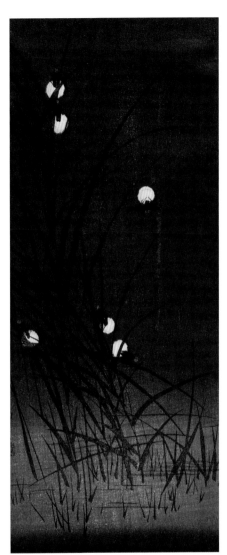

**Soseki (active 1920s)**
*Herons in Rain,* n.d.
Woodcut on paper
Gift of Mr. and Mrs.
William Hepler
AGGV 92.44.9

**Shoka (active 1920s)**
*Fireflies,* n.d.
Woodcut on paper
Gift of Dr. and Mrs.
Morris Shumiatcher
AGGV 2006.013.003

**Elizabeth Keith**
**(British, 1887–1956)**
*Wisteria Bridge, China,* 1925
Woodcut on paper
Senora Ryan Estate
AGGV 91.52.32

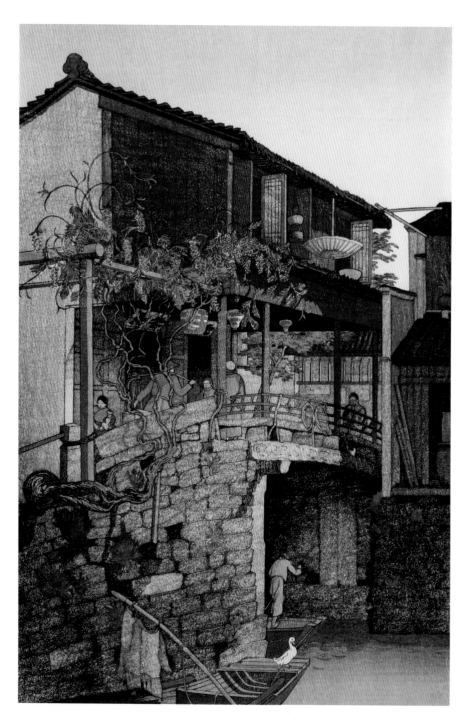

**Elizabeth Keith (British, 1887–1956)**
*Summer Reflections, Kamakura,* 1922
Woodcut on paper
Private collection, intended gift

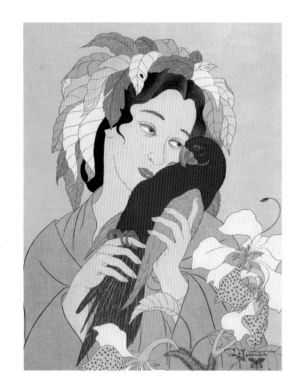

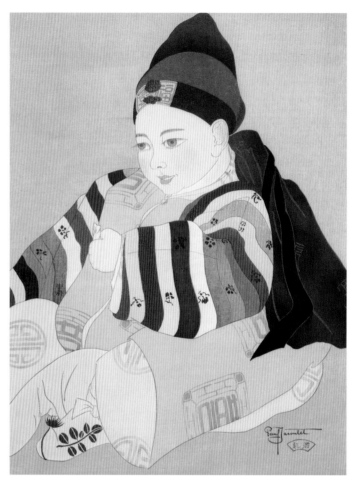

Shin Hanga, The New Print Movement of Japan

**Paul Jacoulet (French, 1902–1960)**
*Chagrins d'Amour,* 1940
Woodcut on paper
Senora Ryan Estate
AGGV 1991.052.001

**Paul Jacoulet (French, 1902–1960)**
*Korean Boy,* 1934
Woodcut on paper
Senora Ryan Estate
AGGV 1992.052.002